The Corset and the Crinoline

A Book of Modes and Costumes from Remote Periods to the Present Time

William Barry Lord

Alpha Editions

This edition published in 2022

ISBN : 9789356012561

Design and Setting By
Alpha Editions
www.alphaedis.com
Email – info@alphaedis.com

As per information held with us this book is in Public Domain.
This book is a reproduction of an important historical work. Alpha Editions uses the best technology to reproduce historical work in the same manner it was first published to preserve its original nature. Any marks or number seen are left intentionally to preserve its true form.

Contents

PREFACE.	- 1 -
CHAPTER I.	- 3 -
CHAPTER II.	- 15 -
CHAPTER III.	- 21 -
CHAPTER IV.	- 32 -
CHAPTER V.	- 47 -
CHAPTER VI.	- 55 -
CHAPTER VII.	- 65 -
CHAPTER VIII.	- 91 -
CHAPTER IX.	- 110 -
CHAPTER X.	- 117 -

PREFACE.

The subject which we have here treated is a sort of figurative battle-field, where fierce contests have for ages been from time to time waged; and, notwithstanding the determined assaults of the attacking hosts, the contention and its cause remain pretty much as they were at the commencement of the war. We in the matter remain strictly neutral, merely performing the part of the public's "own correspondent," making it our duty to gather together such extracts from despatches, both ancient and modern, as may prove interesting or important, to take note of the vicissitudes of war, mark its various phases, and, in fine, to do our best to lay clearly before our readers the historical facts—experiences and arguments—relating to the much-discussed "*Corset question.*"

As most of our readers are aware, the leading journals especially intended for the perusal of ladies have been for many years the media for the exchange of a vast number of letters and papers touching the use of the Corset. The questions relating to the history of this apparently indispensable article of ladies' attire, its construction, application, and influence on the figure have become so numerous of late that we have thought, by embodying all that we can glean and garner relating to Corsets, their wearers, and the various costumes worn by ladies at different periods, arranging the subject-matter in its due order as to dates, and at the same time availing ourselves of careful illustration when needed, that an interesting volume would result.

No one, we apprehend, would be likely to deny that, to enable the fairer portion of the civilised human race to follow the time-honoured custom of presenting to the eye the waist in its most slender proportions, the Corset in some form must be had recourse to. Our information will show how ancient and almost universal its use has been, and there is no reason to anticipate that its aid will ever be dispensed with so long as an elegant and attractive figure is an object worth achieving.

Such being the case, it becomes a matter of considerable importance to discover by what means the desirable end can be acquired without injury to the health of those whose forms are being restrained and moulded into proportions generally accepted as graceful, by the use and influence of the Corset. It will be our duty to lay before the reader the strictures of authors, ancient and modern, on this article of dress, and it will be seen that the animadversions of former writers greatly exceed modern censures, both in number and fierceness of condemnation. This difference probably arises from the fact of Corsets of the most unyielding and stubborn character being universally made use of at the time the severest attacks were made upon

them; and there can be no reasonable doubt that much which was written in their condemnation had some truth in it, although accompanied by a vast deal of fanciful exaggeration. It would also be not stating the whole of the case if we omitted here to note that modern authors, who launch sweeping anathemas on the very stays by the aid of which their wives and daughters are made presentable in society, almost invariably quote largely from scribes of ancient date, and say little or nothing, of their own knowledge. On the other hand, it will be seen that those writing in praise of the moderate use of Corsets take their facts, experiences, and grounds of argument from the every-day life and general custom of the present period.

The Crinoline is too closely associated with the Corset and with the mutable modes affected by ladies, from season to season, to be omitted from any volume which treats of Fashion. The same facts, indeed, may be stated of both the Crinoline and the Corset. Both appear to be equally indispensable to the woman of the present period. To make them serve the purposes of increased cleanliness, comfort, and grace, not only without injury to the health, but with positive and admitted advantage to the *physique*—these are the problems to be solved by those whose business it is to minister to the ever-changing taste and fashion of the day.

CHAPTER I.

The origin of the Corset—The Indian hunting-belt—Reduction of the figure by the ancient inhabitants of Polenqui—Use of the Corset by the natives of the Eastern Archipelago—Improvements in construction brought about by the advance of civilisation—Slenderness of waist esteemed a great beauty in the East—Earth-eating in Java—Figure-training in Ceylon—The beauties of Circassia, their slender waists and Corsets—Elegant princesses of Crim Tartary—Hindoo belles—Hindoo ideas of beauty—Elegance of figure highly esteemed by the Persians—Letter from a Chinese gentleman (Woo-tan-zhin) on slender waists—Researches amongst the antiquities of Egypt—Fashions of the Egyptian ladies—The Corset in use among the Israelitish ladies—The elegance of their costume, bridal dress, &c.—Scriptural references.

FOR the origin of the corset we must travel back into far antiquity. How far it would be difficult to determine. The unreclaimed savage who, bow in hand, threads the mazes of the primeval forests in pursuit of the game he subsists on, fashions for himself, from the skin of some animal which good fortune may have cast in his way, a belt or girdle from which to suspend his rude knife, quiver, or other hunting gear; and experience teaches him that, to answer the purpose efficiently, it should be moderately broad and sufficiently stiff to prevent creasing when secured round the waist. A sharpened bone, or fire-hardened stick, serves to make a row of small holes at each end; a strip of tendon, or a thong of hide, forms a lace with which the extremities are drawn together, thereby giving support to the figure during the fatigues of the chase. The porcupine's quill, the sea-shell, the wild beast's tooth, and the cunningly-dyed root, all help to decorate and ornament the hunting-belt. The well-formed youths and graceful belles of the tribe were not slow in discovering that, when arrayed in all the panoply of forest finery, a belt well drawn in, as shown in the annexed illustration, served to display the figure to much greater advantage than one carelessly or loosely adjusted. Here, then, we find the first indication of the use of the corset as an article of becoming attire. At the very first dawn of civilisation there are distinct evidences of the use of contrivances for the reduction and formation of the female figure. Researches among the ruins of Polenqui, one of the mysterious forest cities of South America, whose history is lost in remote antiquity, have brought to light most singular evidences of the existence of a now forgotten race. Amongst the works of art discovered there is a bas-relief representing a female figure, which, in addition to a profusion of massive ornaments, wears

a complicated and elaborate waist-bandage, which, by a system of circular and transverse folding and looping, confines the waist from just below the ribs to the hips as firmly and compactly as the most unyielding corset of the present day.

At the period of the discovery of some of the islands of the Eastern Archipelago, it was found customary for all young females to wear a peculiar kind of corset, formed of spirally-arranged rattan cane, and this, when once put on, was not removed until the celebration of the marriage ceremony. Such races as were slowly advancing in the march of civilisation, after discovery by the early navigators, became more and more accustomed to the use of clothing, to adjust and retain which, waistbands would become essentially requisite. These, when made sufficiently broad to fit without undue friction, and stiff enough to prevent folding together in the act of stooping, sitting, or moving about, at once became in effect corsets, and suggested to the minds of the ingenious a system of cutting and fitting so as more perfectly to adapt them to the figure of the wearer. The modes of fastening, as we shall see, have been various, from the simple sewing together with the lace to the costly buckle and jewelled loop and stud.

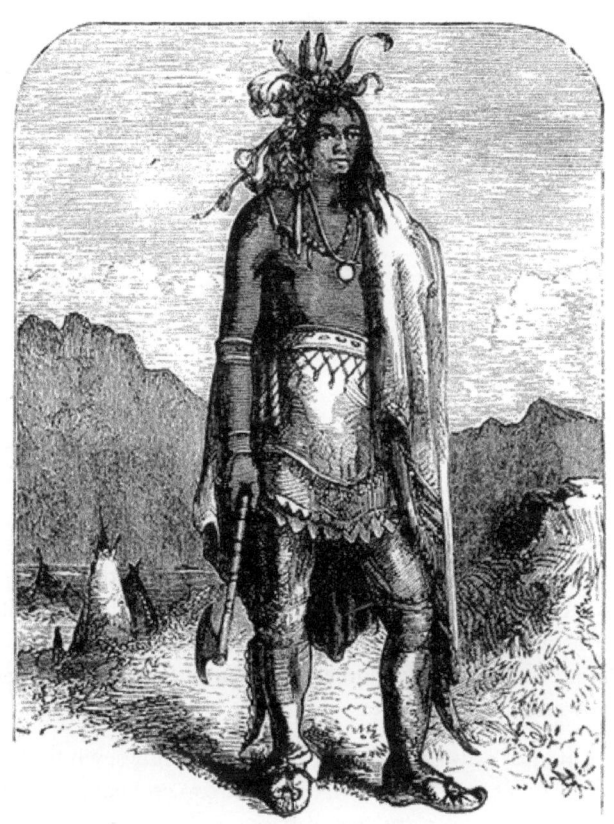

The Dawn of the Corset.

Investigation proves to us that the taste for slender waists prevailed even more in the Eastern nations than in those of Europe, and we find that other means besides that of compression have been extensively taken advantage of. Humboldt, in his personal narrative, describes the women of Java, and informs us that the reddish clay called "*ampo*" is eaten by them in order that they may become slim, want of plumpness being a kind of beauty in that country. Though the use of this earth is fatal to health, those desirous of profiting by its reducing qualities persevere in its consumption. Loss of appetite and inability to partake of more than most minute portions of food are not slow in bringing the wished-for consummation about. The inhabitants of Ceylon make a perfect study of the training of the figure to the most slender proportions. Books on the subject are common in that country, and no young lady is considered the perfection of fashionable elegance unless a great number of qualities and graces are possessed; not the least of these is a waist which can be quite or nearly clasped with the two hands; and, as we

proceed with our work, it will be seen that this standard for the perfection of waist-measurement has been almost world-wide. From the coral-fringed and palm-decked islands of the Pacific and Indian Ocean we have but to travel to the grass-clad Yaila of Crim Tartary and the rock-crowned fastnesses of Circassia, to see the same tastes prevailing, and even more potent means in force for the obtainment of a taper form. Any remarks from us as to the beauty of the ladies of Circassia would be needless, their claim to that enviable endowment being too well established to call for confirmation at our hands, and that no pains are spared in the formation of their figures will be best seen by a quotation from a recent traveller who writes on the subject:—

"What would" (he says) "our ladies think of this fashion on the part of the far-famed beauties of Circassia? The women wear a corset made of 'morocco,' and furnished with two plates of wood placed on the chest, which, by their strong pressure, prevent the expansion of the chest; this corset also confines the bust from the collar-bones to the waist by means of a cord which passes through leather rings. They even wear it during the night, and only take it off when worn out, to put on another quite as small." He then speaks of the daughters of Osman Oglow, and says, "Their figures were tightened in an extraordinary degree, and their *anteries* were clasped from the throat downwards by silver plates."

These plates are not only ornamental, but being firmly sewn to the two busks in front of the corset, and being longest at the top and narrowest at the waist, when clasped, as shown in the accompanying illustration, any change in fit or adjustment is rendered impossible. It will be seen on examination that at each side of the bottom of the corsage is a large round plate or boss of ornamental silver. These serve as clasps for the handsomely-mounted silver waist-belt, and by their size and position serve to contrast with the waist, and make it appear extremely small. That the elegancies of female attire have been deeply studied even among the Tartars of the Crimea will be seen by the following account, written by Madame de Hell, of her visit to Princess Adel Beg, a celebrated Tartar beauty:—

"Admitted into a fairy apartment looking out on a terraced garden, a curtain was suddenly raised at the end of the room, and a woman of striking beauty entered, dressed in rich costume. She advanced to me with an air of remarkable dignity, took both my hands, kissed me on the two cheeks, and sat down beside me, making many demonstrations of friendship. She wore a great deal of rouge; her eyelids were painted black, and met over the nose, giving her countenance a certain sternness, which, nevertheless, did not destroy its pleasing effect. A furred velvet vest fitted tight to her still elegant figure, and altogether her appearance surpassed what I had conceived of her beauty. After some time, when I offered to go, she checked me with a very

graceful gesture, and said eagerly, 'Pastoi, pastoi,' which is Russian for 'Stay, stay,' and clapped her hands several times. A young girl entered at the signal, and by her mistress's orders threw open a folding-door, and immediately I was struck dumb with surprise and admiration by a most brilliant apparition. Imagine, reader, the most exquisite sultanas of whom poetry and painting have ever tried to convey an idea, and still your conception will fall far short of the enchanting models I had then before me. There were three of them, all equally graceful and beautiful. They were clad in tunics of crimson brocade, adorned in front with broad gold lace. The tunics were open, and disclosed beneath them cashmere robes with very tight sleeves, terminating in gold fringes. The youngest wore a tunic of azure-blue brocade, with silver ornaments; this was the only difference between her dress and that of her sisters. All three had magnificent black hair escaping in countless tresses from a fez of silver filigree, set like a diadem over their ivory foreheads. They wore gold-embroidered slippers and wide trousers drawn close at the ankle. I had never beheld skins so dazzlingly fair, eyelashes so long, or so delicate a bloom of youth."

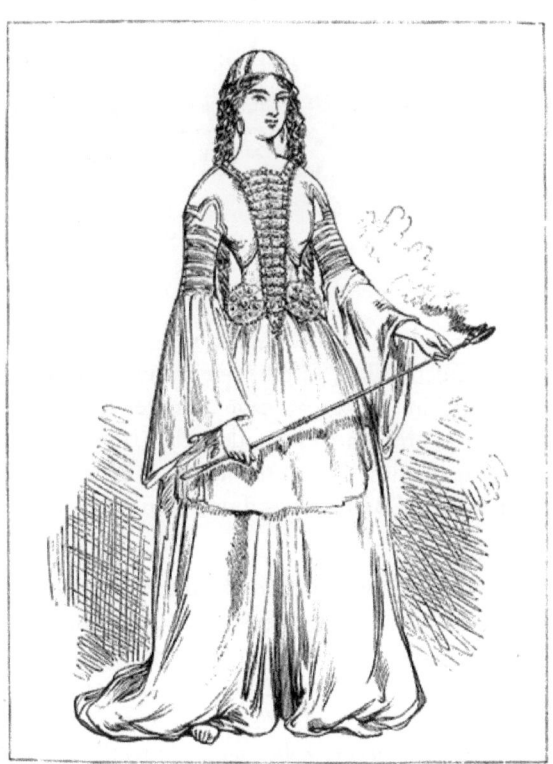

Circassian Lady.

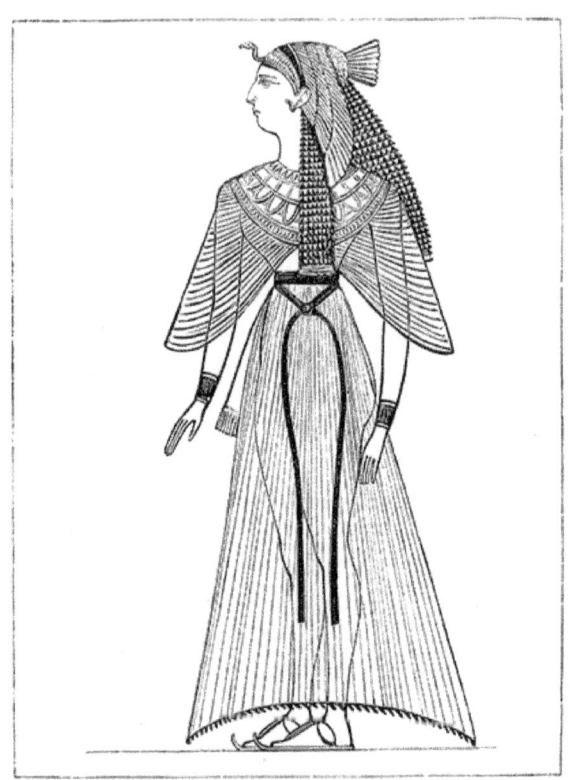

Egyptian Lady in Full Skirt.

The Hindoos subject the figures of their dancing-girls and future belles to a system of very careful training; in all their statues, from those of remote antiquity, to be seen in the great cave temples of Carlee Elanra, and Elephanta, to those of comparatively modern date, the long and slender waist is invariably associated with other attributes of their standard of beauty. "Thurida," the daughter of Brahama, is thus described by a Hindoo writer:—

"This girl" (he informs us) "was of a yellow colour, and had a nose like the flower of resamum; her legs were taper, like the plantain tree; her eyes large, like the principal leaf of the lotus; her eyebrows extended to her ears; her lips were red, and like the young leaves of the mango tree; her face was like the full moon; her voice like the sound of the cuckoo; her arms reached to her knees; her throat was like that of a pigeon; her loins narrow, like those of a lion; her hair hung in curls down to her feet; her teeth were like the seeds of the pomegranate; and walk like that of a drunken elephant or a goose."

The Persians entertain much the same notions with regard to the necessity for slenderness of form in the belles of their nation, but differ in other matters from the Hindoos. The following illustration represents a dancing-girl of Persia, and it will be seen that her figure bears no indication of neglect of cultivation. It is somewhat curious that the Chinese, with all their extraordinary ingenuity, have confined their restrictive efforts to the feet of the ladies, leaving their waists unconfined. That their doing so is more the result of long-established custom than absence of admiration for elegantly-proportioned figures will be clearly proved by the following extract from a letter published in *Chambers' Journal*, written by a genuine inhabitant of the Celestial Empire, named Woo-tan-zhin, who paid a visit to England in 1844-45. Thus he describes the ladies of England:—

"Their eyes, having the blue tint of the waters of autumn, are charming beyond description, and their waists are laced as tight and thin as a willow branch. What, perhaps, caught my fancy most was the sight of elegantly-dressed young ladies, with pearl-like necks and tight-laced waists; nothing can possibly be so enchanting as to see ladies that compress themselves into taper forms of the most exquisite shape, the like of which I have never seen before."

By many writers it has been urged that the admiration so generally felt for slenderly-proportioned and taper waists results from an artificial taste set up by long custom; but in Woo-tan-zhin's case it was clearly not so, as the small-waisted young ladies of the "outer barbarians" were to him much as some new and undescribed flowers or birds would be to the wondering naturalist who first beheld them.

Although researches among the antiquities of Egypt and Thebes fail to bring to our notice an article of dress corresponding with the waist-bandage of Polenqui or the strophium of later times, we find elaborately-ornamented waistbelts in general use, and by their arrangement it will be seen that they were so worn as to show the waist off to the best advantage. The accompanying illustrations represent Egyptian ladies of distinction. The dress in the first, it will be observed, is worn long. A sort of transparent mantle covers and gives an appearance of width to the shoulders, whilst a coloured sash, after binding the waist, is knotted in front, and the ends allowed to fall freely over the front of the dress, much as we have seen it worn in our own time; and it is most remarkable that, although there is no evidence to show the use of crinoline by the ladies of old Egypt, the lower border of the skirt, in some instances, appears distended as in the prior illustration; whilst in others, as shown in the second engraving, the dress is made to fit the lower portion of the figure closely, barely affording scope for the movement of the legs in walking. How often these arrangements of dress have been in turn adopted and discarded will be seen as our work proceeds.

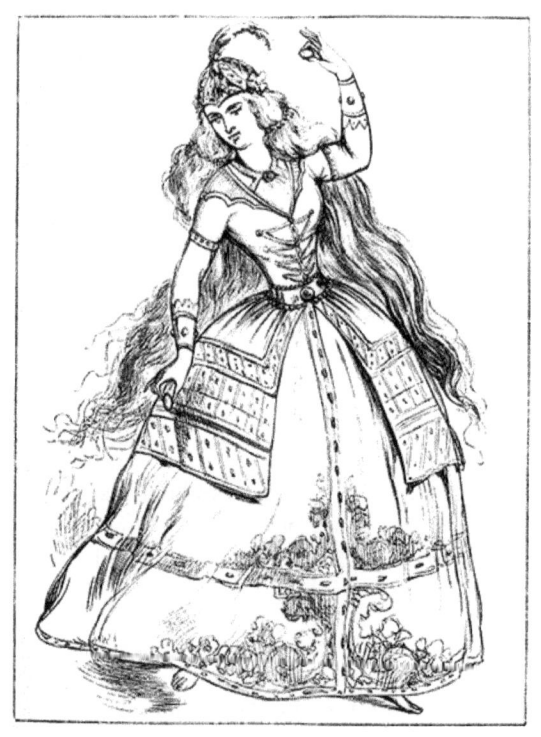

Persian Dancing Girl.

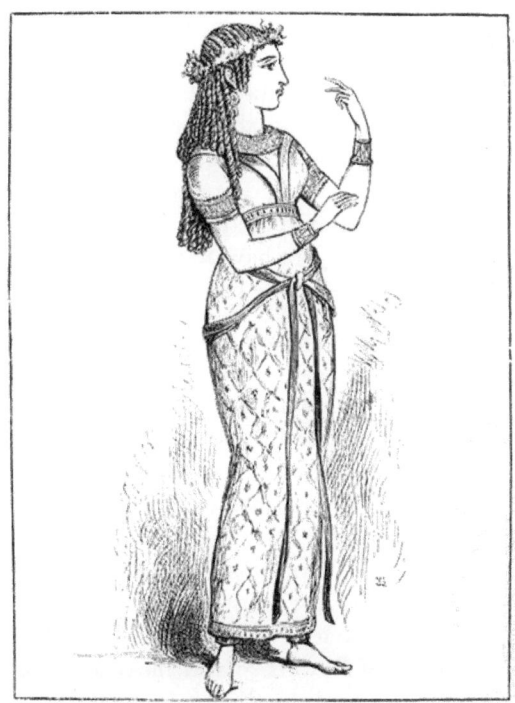

Egyptian Lady in Narrow Skirt.

The following extract from Fullam will show that Fashion within the shadow of the Pyramids, in the days of the Pharaohs, reigned with power as potent and supreme as that which she exercises in the imperial palaces of Paris and Vienna at the present day:—

"The women of Egypt early paid considerable attention to their toilet. Their dress, according to Herodotus, consisted usually of but one garment, though a second was often added. Among the upper orders the favourite attire was a petticoat tied round the waist with a gay sash, and worn under a robe of fine linen or a sort of chintz variously coloured, and made large and loose, with wide sleeves, the band being fastened in front just under the bust. Their feet were incased in sandals, the rudiment of the present Eastern slipper, which they resembled also in their embroidery and design. Their persons and apparel, in conformity with Oriental taste in all ages, were profusely decked with ornaments, 'jewels of silver and jewels of gold,' with precious gems of extraordinary size, of which imitations, hardly distinguishable from the real stones, were within the reach of the humblest classes, whose passion for finery could not be surpassed by their superiors. The richly carved and embroidered sandals, tied over the instep with tassels of gold, were

surmounted by gold anklets or bangles, which, as well as the bracelets encircling the wrist, sparkled with rare gems; and necklaces of gold or of beautiful beads, with a pendant of amethysts or pearls, hung from the neck. Almost every finger was jewelled, and the ring finger in particular was usually allotted several rings, while massive earrings shaped like hoops, or sometimes taking the form of a jewelled asp or of a dragon, adorned the ears. Gloves were used at a very early date, and among the other imperishable relics of that olden time the tombs of Egypt have rendered up to us a pair of striped linen mittens, which once covered the hands of a Theban lady.

"Women of quality inclosed their hair with a band of gold, from which a flower drooped over the forehead, while the hair fell in long plaits to the bosom, and behind streamed down the back to the waist. The side hair was secured by combs made of polished wood or by a gold pin, and perhaps was sometimes adorned, like the brow, with a favourite flower. The toilet was furnished with a brazen mirror, polished to such a degree as to reflect every lineament of the face, and the belles of Egypt, as ladies of the present day may imagine, spent no small portion of their time with this faithful counsellor. The boudoirs were not devoid of an air of luxury and refinement particularly congenial to a modern imagination. A stand near the unglazed window supported vases of flowers, which filled the room with delicious odours; a soft carpet overspread the floor; two or three richly-carved chairs and an embroidered fauteuil afforded easy and inviting seats; and the lotus and papyrus were frescoed on the walls. Besides the brazen mirror, other accessories of the toilet were arranged on the ebony table, and boxes and caskets grotesquely carved, some containing jewels, others furnished with oils and ointments, took their place with quaintly-cut smelling bottles, wooden combs, silver or bronze bodkins, and lastly, pins and needles.

"Seated at this shrine, the Egyptian beauty, with her dark glance fixed on the brazen mirror, sought to heighten those charms which are always most potent in their native simplicity. A touch of collyrium gave illusive magnitude to her voluptuous eyes; another cosmetic stained their lids; a delicate brush pencilled her brows—sometimes, alas! imparted a deceitful bloom to her cheeks; and her taper fingers were coloured with the juice of henna. Precious ointments were poured on her hair, and enveloped her in an atmosphere of perfume, while the jeweller's and milliner's arts combined to decorate her person."

In Sir Gardner Wilkinson's admirable work on ancient Egypt, to which I am indebted for some valuable information, there is a plate representing a lady in a bath with her attendants, drawn from a sculpture in a tomb at Thebes, whence we may derive some faint idea of the elaborate character of an Egyptian toilet.

The lady is seated in a sort of pan, with her long hair streaming over her shoulders, and is supported by the arm of an attendant, who, with her other hand, holds a flower to her nose, while another damsel pours water over her head, and a third washes and rubs down her delicate arms. A fourth maiden receives her jewels, and deposits them on a stand, where she awaits the moment when they will be again required.

There appears little doubt that the ancient Israelitish ladies, amongst their almost endless and most complex articles of adornment, numbered the corset in a tolerably efficient form, and of attractive and rich material, for we read in the twenty-fourth verse of the third chapter of Isaiah, referring to Divine displeasure manifested against the people of Jerusalem and Judah, and the taking away of matters of personal adornment from the women, that "instead of a girdle there should be a rent, and instead of well-set hair baldness, and instead of a stomacher a girding of sackcloth, and burning instead of beauty." Here we have the coarse, repulsive, unattractive sackcloth held up in marked contrast to the stomacher, which was without question a garment on which much attention was bestowed; and the following extract from Fullam's *History of Woman* shows how costly and magnificent was the costume of the period:—

"The bridal dress of a princess or Jewish lady of rank, whose parents possessed sufficient means, was of the most sumptuous description, as may be seen from the account given of that worn by the bride of Solomon in the Canticles, and the various articles enumerated show the additions which feminine taste had already made to the toilet. The body was now clothed in a bodice ascending to the network which inclosed, rather than concealed, the swelling bust; and jewelled clasps and earrings, with strings of pearls and chains of gold, gave a dazzling effect to Oriental beauty. In Solomon's reign silk is said to have been added to the resources of the toilet, and the sex owe to a sister, Pamphyla, the daughter of Patous, the discovery of this exquisite material, in which woman wrested from Nature a dress worthy of her charms.

"The ordinary attire of Jewish women was made of linen, usually white, without any intermixture of colours, though, in accordance with the injunction in Numbers xv. 38, they made 'fringes in the borders of their garments,' and 'put upon the fringe of the borders a riband of blue.' Judith, when she sought to captivate Holofernes, 'put on her garments of gladness, wherewith she was clad during the life of Manasses her husband; and she took sandals upon her feet, and put about her bracelets, and her chains, and her rings, and her earrings, and all her ornaments, and decked herself bravely to allure the eyes of all men that should see her.' Gemmed bangles encircled her ankles, attracting the glance to her delicate white feet; and Holofernes, by an Oriental figure of speech, is said to have been 'ravished by the beauty of her sandals.' Like the belles of Egypt she did not disdain, in setting off her

charms, to have recourse to perfumes and cosmetics, and previously to setting out she 'anointed herself with precious ointment.' In another place Jezebel is said to 'paint her eyelids;' and Solomon, in the Proverbs, in describing the deceitful woman, adjures his son not to be 'taken with her eyelids,' evidently alluding to the use of collyrium. The Jewish beauty owed no slight obligation to her luxuriant tresses, which were decorated with waving plumes and strings of pearls; and in allusion to this custom, followed among the tribes from time immemorial, St. Paul affirms that 'a woman's ornament is her hair.' Judith 'braided the hair of her head and put a tire upon it;' and the headdress of Pharaoh's daughter, in the Canticles, is compared by Solomon to Carmel. No mention is made of Judith's mirror, but it was undoubtedly made of brass, like those described in Exodus xxxviii. 8 as 'the looking-glasses of the women which assembled at the door of the tabernacle of the congregation.'"

CHAPTER II.

Homer the first ethnic writer who speaks of an article of dress allied to the Corset—The cestus or girdle of Venus—Terentius, the Roman dramatist, and his remarks on the practice of tight-lacing—The use of the strophium by the ladies of Rome, and the mitra of the Grecian belles—The peplus as worn by the ancients—Toilet of a Roman lady of fashion—Roman baths—Fashionable promenades of Ancient Rome—Boundless luxury and extravagance—Cleopatra and her jewels—The taper waists and tight-lacing of the ancient Roman ladies—Conquest of the Roman Empire.

AMONGST the ethnic writers, Homer appears to be the first who describes an article of female dress closely allied to the corset. He tells us of the cestus or girdle of Venus, mother of the Loves and Graces, and of the haughty Juno, who was fabled to have borrowed it with a view to the heightening and increasing her personal attractions, in order that Jupiter might become a more tractable and orderly husband. The poet attributes most potent magical virtues to the cestus, but these are doubtlessly used in a figurative sense, and Juno, in borrowing the cestus, merely obtained from a lady of acknowledged elegance of figure a corset with which to set her own attractions off to the best possible advantage, so that her husband might be charmed with her improved appearance; and Juno appears to have been a very far-seeing and sensible woman. From periods of very remote antiquity, and with the gradual increase of civilisation, much attention appears to have been paid to the formation and cultivation of the female figure, and much the same means were had recourse to for the achievement of the same end prior to 560 B.C. as in the year 1868. Terentius, the Roman dramatist, who was born in the year 560, causes one of his characters, in speaking of the object of his affections, to exclaim—

"This pretty creature isn't at all like our town ladies, whose mothers saddle their backs and straitlace their waists to make them well-shaped. If any chance to grow a little plumper than the rest, they presently cry, 'She's an hostess,' and then her allowance must be shortened, and though she be naturally fat and lusty, yet by her dieting she is made as slender as a broomstick. By this means one woodcock or another is caught in their springe."

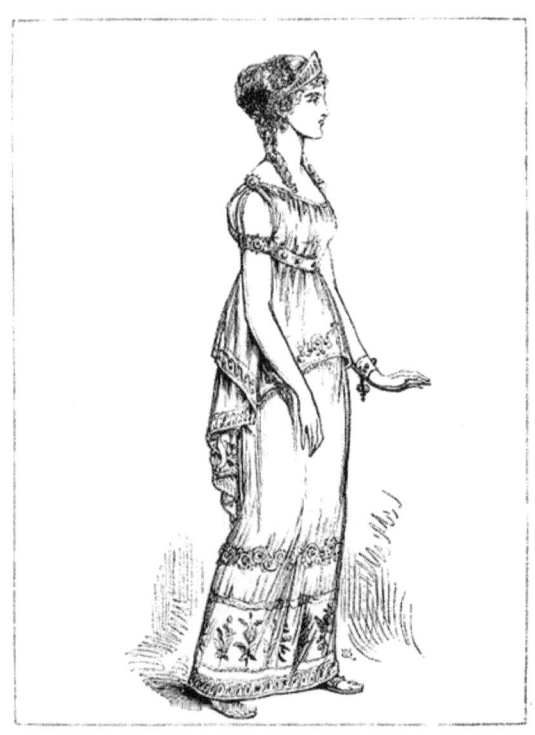

Lady of Ancient Greece.

Strutt informs us that the Roman women, married as well as unmarried, used girdles, and besides them they sometimes wore a broad swath or bandage round their breasts, called strophium, which seems to have answered the purpose of the bodice or stays, and had a buckle or bandage on the left shoulder, and that the mitra or girdle of the Greeks probably resembled the strophium of the Romans. The annexed illustration represents a lady of Ancient Greece. He also speaks of the Muses as being described by Hesiod as being girt with golden "*mitres*," and goes on to inform us that Theocritus in one of his pastorals introduces a damsel complaining to a shepherd of his rudeness, saying he had loosened her mitra or girdle, and tells her he means to dedicate the same to Venus. So it will be seen that the waist and its adornment were considered at that early period of the world's history matters of no ordinary importance, and whether the term strophium, zone, mitra, custula, stays, bodice, or corset is made use of, the end sought to be obtained by their aid was the same.

Constant mention is made by early writers of the *peplus* as being a very elegant garment, and there are notices of it as back as the Trojan war, and the ladies

of Troy appear to have generally worn it. On the authority of Strutt, it may be stated to have been "a thin light mantle worn by Grecian ladies above the tunic;" and we read that Antinous presented to Penelope a beautiful large and variegated peplus, having twelve buckles of gold, with tongues neatly curved. The peplus, however, was a very splendid part of the lady's dress, and it is rarely mentioned by Homer without some epithet to distinguish it as such. He calls it the *variegated* peplus and the painted peplus, alluding to ornamental decorations either interwoven or worked with the needle upon it, which consisted not only in diversity of colours, but of flowers, foliage, and other kinds of imagery, and sometimes he styles it the *soft purple peplus*, which was then valuable on account of the excellence of the colour. We learn from a variety of sources that the early Roman and Grecian ladies indulged in almost unprecedented luxury in matters of personal adornment, as the following extract from Fullam will show:—

"The toilet of a Roman lady involved an elaborate and very costly process. It commenced at night, when the face, supposed to have been tarnished by exposure, was overlaid with a poultice, composed of boiled or moistened flour spread on with the fingers. Poppæan unguents sealed the lips, and the body was profusely rubbed with Cerona ointment. In the morning the poultice and unguents were washed off; a bath of asses' milk imparted a delicate whiteness to the skin, and the pale face was freshened and revived with enamel. The full eyelids, which the Roman lady still knows so well how to use—now suddenly raising them, to reveal a glance of surprise or of melting tenderness, now letting them drop like a veil over the lustrous eyes—the full, rounded eyelids were coloured within, and a needle dipped in jetty dye gave length and sphericity to the eyebrows. The forehead was encircled by a wreath or fillet fastened in the luxuriant hair which rose in front in a pyramidal pile formed of successive ranges of curls, and giving the appearance of more than ordinary height.

"'So high she builds her head, she seems to be,

 View her in front, a tall Andromache;

 But walk all round her, and you'll quickly find

 She's not so great a personage behind.'

"Roman ladies frequented the public baths, and it was not unusual for dames of the highest rank to resort to these lavatories in the dead hour of the night. Seated in a palanquin or sedan borne by sturdy chairmen, and preceded by slaves bearing flambeaux, they made their way through the deserted streets, delighted to arouse and alarm their neighbours. A close chair conveyed the patrician matron to the spectacles and shows, to which she always repaired

in great state, surrounded by her servants and slaves, the dependants of her husband, and the clients of her house, all wearing the badge of the particular faction she espoused. The factions of the circus were four in number, and were distinguished by their respective colours of blue, green, white, and red, to which Domitian, who was a zealous patron of the Circensian games, added the less popular hues of gold and purple. But the spectators generally attached themselves either to the blue or the green, and the latter was the chief favourite, numbering among its adherents emperors and empresses, senators, knights, and noble dames, as well as the great mass of the people, who, when their champions were defeated, carried their partisanship to such an extreme that the streets were repeatedly deluged with the blood of the blues, and more than once the safety of the state was imperilled by these disgraceful commotions.

"The public walks and gardens were a fashionable resort of the Roman ladies. There they presented themselves in rich costume, which bore testimony alike to the wealth of their husbands and their own taste. A yellow tire or hood partly covered, but did not conceal, their piled hair; their vest of muslin or sarcenet, clasped with gems, was draped with a murry-coloured robe descending to their high-heeled Greek boots; necklaces of emerald hung from their swan-like necks, and jewelled earrings from their ears; diamonds glittered on their fingers, and their dazzling complexions were shielded from the sun by a parasol."

The researches of Strutt show us that the shoes of the ladies, and especially among the Romans, proved a very expensive part of the dress. In general they were white, but persons of opulence did not confine themselves to any colour. We find them black, scarlet, purple, yellow, and green. They were often not only richly adorned with fringes and embroideries of gold, but set with pearls and precious stones of the most costly kind, and these extravagances were not confined to persons of rank. They were imitated by those of lower station, and became so prevalent at the commencement of the third century, that even the luxurious Emperor Heliogabalus thought it necessary to publish an edict prohibiting the use of such expensive shoes excepting to women of quality. The women wore the close shoe or *calceus*. Gloves, too, as we have seen before, were known and used in very early ages, and it appears probable that they were first devised by those whose labours called them to the thick-tangled thorn coverts, but that they were worn by those who did not labour is clearly proved by Homer, who describes the father of Ulysses when living in a state of rest as wearing gloves; but he gives us no information as to the material from which they were manufactured. The Romans appear to have been much more addicted to the practice of wearing gloves than the Greeks, and we are informed that "under the emperors they were made with fringes," though others were without them,

and were fashioned much after the manner of the mittens of the present day. Further on we learn that "as riches and luxury increased, the lady's toilet was proportionately filled with ornaments for the person, so that it was called '*the woman's world*.'" They not only anointed the hair and used rich perfumes, but sometimes they *painted it*. They also made it appear of a bright yellow colour by the assistance of washes and compositions made for that purpose; but they never used powder, which is a much later invention. They frizzled and curled the hair with hot irons, and sometimes they raised it to a great height by rows of curls one above another in the form of a helmet, and such as had not sufficient hair of their own used false hair to complete the lofty pile, and these curls appear to have been fashioned with hairpins. The Grecian virgins used to braid their hair in a multiplicity of knots, but that custom, as well as painting the under part of the eyelids with black paint, was discommended by an ancient poet. Persons of rank had slaves to perform for them the offices of the toilet. They held the mirror in their hand themselves and gave directions, and Martial tells us that, if the slaves unfortunately placed a hairpin wrong, or omitted to twist the curls exactly as they were ordered, the mirror was thrown at the offender's head, or, according to Juvenal, the whip was applied with much severity. The hair was adorned with ornaments of gold, with pearls and precious stones, and sometimes with garlands or chaplets of flowers. It was also bound with fillets and ribbons of various colours and kinds. The net or hair-caul for the purpose of inclosing the hinder part of the hair was in general use with the Grecian and Roman ladies. These ornaments were frequently enriched with embroidery, and sometimes made so thin that Martial sarcastically called them "*bladders*."

Again, in the matter of *earrings*, we quote from the same valuable and trustworthy authority. No adornment of the head claims priority to earrings. They have been fashionable, as Montfaucon justly observes, in all ages and almost all nations. It is evident from Homer that the Grecian women bored their ears for the admission of these ornaments. The poet gives earrings to the goddess Juno, and the words he uses on the occasion are literally these:— "In her well-perforated ears she put the earrings of elaborate workmanship, having three eyes in each"—that is, three pendants or jewels, either made in the form of eyes, or so called from their brightness. The extravagance of the Grecian and Roman ladies in the purchase of these articles of adornment almost exceeds belief. Pliny says, "They seek for pearls at the bottom of the Red Sea, and search the bowels of the earth for emeralds to ornament their ears;" and Seneca tells us that "a single pair of earrings was worth the revenue of a large estate, and that some women would wear at their ears the price of two or three patrimonies." We read that the earrings worn by Cleopatra were valued at £161,458, and that Servilia, the mother of Brutus, was presented with a pair by Julius Cæsar, the value of which was £48,457.

Bracelets are also ornaments of high antiquity, as are rings and brooches of various forms for fastening the dress.

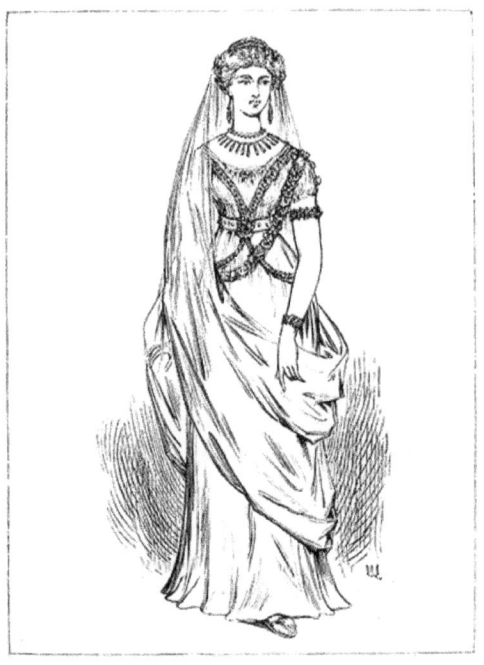

Roman Lady of Rank (Reign of Heliogabalus).

Rich gold chains and jewelled fastenings were in common use during this period. The annexed illustration represents a Roman lady of rank about the reign of Heliogabalus. Little alteration appears to have taken place in the general style of costume for some very considerable period of time, and the patrician ladies concealed beneath their flowing draperies a kind of corset, which they tightened very considerably, for a slight and tapering waist was looked upon as a great beauty in women, and great attention was paid to the formation of the figure, in spite of all that has been written about the purely natural and statuesque forms of the Roman matrons. On the conquest of the Roman Empire by the wild and savage Hunnish tribes, fashion, art, taste, literature, and civilisation were swept ruthlessly away, and a long, weird night of mental darkness may be said to have reigned throughout the land from the tenth to the middle of the fifteenth century, and we see little or nothing of Roman elegance or magnificence of dress to distinguish it above other nations from that period.

CHAPTER III.

The ladies of Old France—Their fashions during the reign of King Pepin—Revival of the taste for small waists—Introduction of "*cottes hardies*"—Monkish satire on the Corset in England in the year 1043, curious MS. relating to—The small waists of the thirteenth century—The ancient poem of *Launfal*—The Lady Triamore, daughter of the King of the Fairies—Curious entry in the household register of Eleanor, Countess of Leicester, date 1265—Corsets worn by gentlemen at that period—The kirtle as worn in England—The penance of Jane Shore—Dress of Blanche, daughter of Edward III—Dunbar's *Thistle and Rose*—Admiration for small waists in Scotland in the olden time—Chaucer's writings—Small waists admired in his day—The use of the surcoat in England—Reckless hardihood of a determined tailor—The surcoat worn by Marie d'Anjou of France—Italian supremacy in matters of dress—The Medici, Este, and Visconti—Costume of an Italian duchess described—Freaks of fashion in France and Germany—Long trains—Laws to restrain the length of skirts—Snake-toed shoes give place to high-heeled slippers.

RESEARCH fails to show us that the ladies of France in their simple Hersvingian and Carlovingian dresses paid any attention to the formation of the waist or its display. But during the ninth century we find the dresses worn extremely tight, and so made as to define the waist and render it as slim as possible; and although the art of making the description of corsets worn by the ladies of Rome was no doubt at that time lost, the revived taste for slender figures led to the peculiar form of corsage known as *cottes hardies*, which were much stiffened and worn extremely tight. These took the place of the quaint, oddly-formed robes we see draping the figures of Childeric's and Pepin's queens. The "*cottes hardies*" were, moreover, clasped at the waist by a broad belt, and seem pretty well to have merited their martial name. Very soon after this period it is probable that a much more complete description of corset was invented, although we do not find any marked representation of its form until 1043. A manuscript of that date at present in the British Museum bears on it the strange and anomalous figure represented in the annexed illustration. Opinions vary somewhat as to whether its origin might not have been Italian, but we see no reason for adopting this view, and consider it as of decidedly home production. It will be seen that the shoulder, upper part of the arm, and figure are those of a well-formed female, who wears an unmistakable corset, tightly laced, and stiffened by two busks in

front, from one of which the lace, with a tag at the end, depends. The head, wings, tail, feet, and claws are all those of a demon or fiend. The drapery is worn so long as to render large knots in it requisite to prevent dragging on the ground. The ring held in the left claw is of gold, and probably intended to represent a massive and costly bracelet. Produced, as this MS. appears to have been, during the reign of Edward the Confessor, there is little doubt that it was a severe monkish satire on the prevailing fashion, and a most ungallant warning to the male sex that alabaster shoulders and slender waists were too often associated with attributes of a rather brimstone character, and that an inordinate love of long, trailing garments and ornaments of precious metals were snares and enticements of a sinister nature. Many of the figures to be found on ancient MSS. after this period show by their contour that the corset was worn beneath the drapery, and Strutt, whose work was published in 1796, thus writes of the customs relating to dress in the period following shortly after:—"In the thirteenth century, and probably much prior to that period, a long and slender waist was considered by our ancestors as a criterion of elegance in the female form. We ought not, therefore, to wonder if it be proved that the tight lacing and compressing of the body was practised by the ladies even in early times, and especially by such of them as were inclined to be corpulent." He then, in order to show at what an early date of the history of this country a confirmed taste for small waists existed, quotes from a very ancient poem, entitled *Launfal*, in which the Lady Triamore, daughter of the King of the Fairies, and attendant ladies are described. Of two of the latter it is said—

"Their kirtles were of rede cendel,

 I laced smalle, jollyf, and well,

 There might none gayer go."

A rich description of silk.

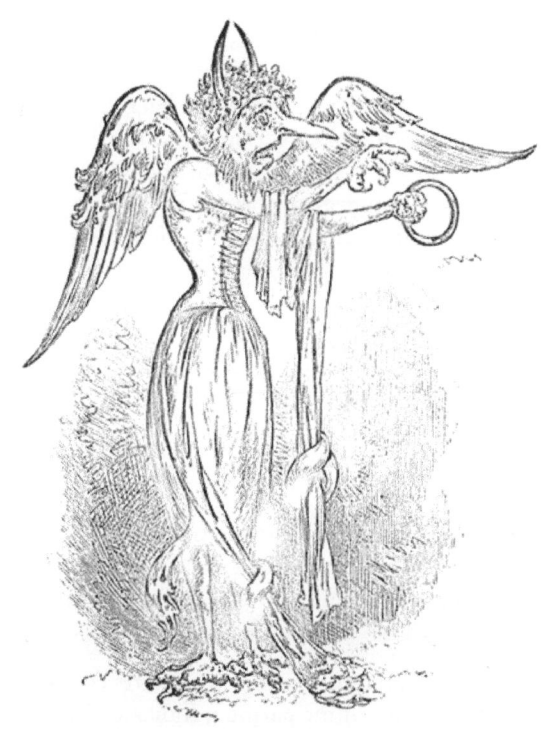

The Fiend of Fashion, from an Ancient Manuscript.

In the French version of the same poem it is, we read, more fully expressed. It says, "They were richly habited and very tightly laced." The Lady Triamore is thus described:—

"The lady was in a purple pall,
 With gentill bodye and middle small."

Wharton quotes from an ancient poem, which he believes to date as far back as 1200, in which a lover, speaking of the object of his admiration, thus throws down the gauntlet of challenge, and exclaims—

"Middle her she hath mensk small."

The word *mensk* or *maint* being used instead of very or much. Some differences of opinion have existed among writers as to the origin of the word *corset*. Some are of opinion that the French words *corps*, the body, and *serrer* (to tightly inclose or incase), led to the adoption of the term. Madame La Sante gives it as her opinion, however, that it is more probably a

corruption of the single word *corps*, which was formerly written *cors*, and may be taken as a diminutive form of it. Another view of the matter has been that the name of a rich material called *corse*, which was at one time extensively used in the manufacture of corsets, may have been thus corrupted. This is scarcely probable, as the word corset was in use at too early a period to admit of that origin. Perhaps as early an instance of the use of the term corset as any in existence may be found as a portion of an entry in the household register of Eleanor, Countess of Leicester, which bears the date May 24, 1265:—

"Item: Pro ix ulnis radii. Pariensis pro robas æstivas corsetto et clochia pro eodem."

Item: For nine ells, Paris measure, for summer robes, corsets, and cloaks for the same.

The persons for whom these garments were made were Richard, King of the Normans, and Edward, his son, whose death occurred in the year 1308. So that corsets were, even in those early days, used by gentlemen as well as ladies.

The term kirtle, so often referred to, may not clearly convey to the mind of the modern reader the nature of the garment indicated by it, and therefore it may not be amiss to give Strutt's description of it. He says, "The kirtle, or, as it was anciently written '*kertel*,' is a part of the dress used by the men and the women, but especially by the latter. It was sometimes a habit of state, and worn by persons of high rank." The garment sometimes called a "*surcol*" Chaucer renders *kirtle*, and we have no reason to dispute his authority. Kirtles are very frequently mentioned in old romances. They are said to have been of different textures and of different colours, but especially of green; and sometimes they were laced closely to the body, and probably answered the purpose of the bodice or stays—*vide Launfal*, before referred to:—

"Their kirtles were of rede cendel,

I laced smalle, jollyf, and well."

To appear in a kirtle only seems to have been a mark of servitude. Thus the lady of Sir Ladore, when he feasted the king, by way of courtesy waited at the table—

"The lady was gentyll and small,

In kirtle alone she served in hall."

We are further informed that at the close of the fifteenth century it was used as a habit of penance, and we read that Jane Shore, when performing penance, walked barefoot, a lighted taper in her hand, and having only her kirtle upon her back. John Gower, however, who wrote at about the same period as Chaucer, thus describes a company of ladies. They were, says he, "clothed all alike, in kirtles with rich capes or mantles, parti-coloured, white, and blue, embroidered all over with various devices." Their bodies are described as being long and small, and they had crowns of gold upon their heads, as though each of them had been a queen. We find that the tight-laced young ladies of the court of the Lady Triamore "had mantles of green-coloured velvet, handsomely bordered with gold, and lined with rich furs. Their heads were neatly attired in kerchiefs, and were ornamented with cut work and richly-striped wires of gold, and upon their kerchiefs they had each of them a pretty coronal, embellished with sixty gems or more;" and of their pretty mistress it is said in the same poem, that her cheeks were as red as the rose when it first blossoms. Her hair shone upon her head like golden wire, falling beneath a crown of gold richly ornamented with precious stones. Her vesture was purple, and her mantle, lined with white ermine, was also elegantly furred with the same. The Princess Blanche, the daughter of Edward III., the subject of the annexed illustration, appears to have copied closely the dress above described, and, like the maids of honour of the Lady Triamore herself, she is not only richly habited but thoroughly well-laced as well. Thus we see, in the year 1361, the full influence of the corset on the costume of that period. There is another poem, said to be more ancient than even *Launfal*, which, no doubt, served to give a tone and direction to the fashions of times following after. Here we find a beautiful lady described as wearing a splendid girdle of beaten gold, embellished with rubies and emeralds, about her *middle small*.

The Princess Blanche, Daughter of Edward III.

Gower, too, when describing a lover who is in the act of admiring his mistress, thus writes:—

"He seeth hir shape forthwith, all

 Hir bodye round, hir middle small."

That the taste for slender figures was not confined to England will be shown by the following quotation from Dunbar's *Thistle and Rose*. When the belles of Scotland grouped together are described he tells us that

"Their middles were as small as wands."

A great number of ancient writings descriptive of female beauty go clearly to prove that both slenderness and length of waist were held in the highest esteem and considered indispensable elements of elegance, and there can be no question that such being the case no pains were spared to acquire the

coveted grace a very small, long, and round waist conferred on its possessor. The lower classes were not slow in imitating their superiors, and the practice of tight lacing prevailed throughout every grade of society. This was the case even as far back as Chaucer's day, about 1340. He, in describing the carpenter's wife, speaks of her as a handsome, well-made young female, and informs us that "her body was genteel" (or elegant) and "small as a weasel," and immediately afterwards that she was

"Long as a maste, and upright as a bolt."

Notwithstanding the strict way in which the waist was laced during the thirteenth century, the talents of the ingenious were directed to the construction of some article of dress which should reduce the figure to still more slender proportions, and the following remarks by Strutt show that tight lacing was much on the increase from the thirteenth to the fourteenth centuries. He says—

"A small waist was decidedly, as we have seen before, one criterion of a beautiful form, and, generally speaking, its length was currently regulated by a just idea of elegance, and especially in the thirteenth century. In the fourteenth the women seem to have contracted a vitiated taste, and not being content with their form as God hath made it, introduced the corset or bodice—a stiff and unnatural disguisement even in its origin."

Lady of Rank of the Thirteenth Century.

How far this newly-introduced form of the corset became a "disguisement" will be best judged of by a glance at the foregoing illustration, which represents a lady in the dress worn just at the close of the thirteenth century. The term *surcoat* was given to this new introduction. This in many instances was worn over the dress somewhat after the manner of the body of a riding-habit, being attached to the skirt, which spreads into a long trailing train. An old author, speaking of these articles of dress, thus writes:—

"There came to me two women wearing *surcoats*, longer than they were tall by about a yard, so that they were obliged to carry their trains upon their arms to prevent their trailing upon the ground, and they had sleeves to these surcoats reaching to the elbows."

The trains of these dresses at length reached such formidable dimensions that Charles V. of France became so enraged as to cause an edict to be issued hurling threats of excommunication at the heads of all those who dared to wear a dress which terminated "like the tail of a serpent."

Notwithstanding this tremendously alarming threat, a tailor was found fully equal to the occasion, who, in spite of the terrors inspired by candle, bell, and book, set to work (lion-hearted man that he was) and made a magnificent surcoat for Madame du Gatinais, which not only trailed far behind on the ground, but actually "took *five yards of Brussels net for sleeves, which also trailed.*" History, or even tradition, fails to inform us what dreadful fate overtook this desperate tailor after the performance of a feat so recklessly daring; but we can scarcely fancy that his end could have been of the kind common to tailors of less audacious depravity.

The bodies of these surcoats were very much stiffened, and so made as to admit of being laced with extreme tightness. They were often very richly ornamented with furs and costly needlework. As fashion changed, dresses were made with open fronts, so as to be worn over the surcoat without altogether concealing it. A portrait of Marie d'Anjou, Queen of France, shows this arrangement of costume. The waist appears very tightly laced, and the body of the surcoat much resembles the modern bodice, but is made by stiffening and cut to perform the part of a very strong and efficient corset. Until the termination of the fourteenth century very little change appears to have been made either in costume or the treatment of the figure, but at the commencement of the fifteenth century, when such noble families as the Medici, Este, and Visconti established fashions and styles of costume for themselves, each house vied with the other in the splendour of their apparel. The great masters of the period, by painting ideal compositions, also gave a marked tone to the increasing taste for dress. The costume of an Italian duchess, whose portrait is to be seen in the Academy at Pisa, has been thus described:—"The headdress is a gold coronet, the chemisette is finely interwoven with gold, the under-dress is black, the square bodice being bordered with white beads, the over-dress is gold brocade, the sides are open, and fastened together again with gold *agrafes*; the loose sleeves, like the chemisette, are of golden tissue, fastened to the shoulders with *agrafes*. The under-sleeves, which are of peculiar construction, and are visible, are crimson velvet, and reach to the centre of the hand. They are cut out at the wrists, and white puffings of the same material as the chemisette protrude through the openings." In both France and Germany a great many strange freaks of fashion appear to have been practised about this time. The tight, harlequin-like dress was adopted by the gentlemen, whilst the long trains again stirred the ire of royalty. We find Albert of Saxony issuing the following laws:—"No wives or daughters of knights are to wear dresses exceeding one yard and a-half in length, no spangles in their caps, nor high frills round their throats." During the reign of the Dauphin in France many changes in dress were effected. The length of the sleeves was much curtailed, and the

preposterously long toes of the shoes reduced to a convenient standard. The ladies appear to have for some time resisted the innovation, but one Poulaine, an ingenious Parisian shoemaker, happening to devise a very attractive shoe with a heel fitted to it, the ladies hailed joyfully the new favourite, and the old snake-toed shoe passed away. Still, it was no uncommon thing to see some fop of the period with one shoe white and the other black, or one boot and one shoe.

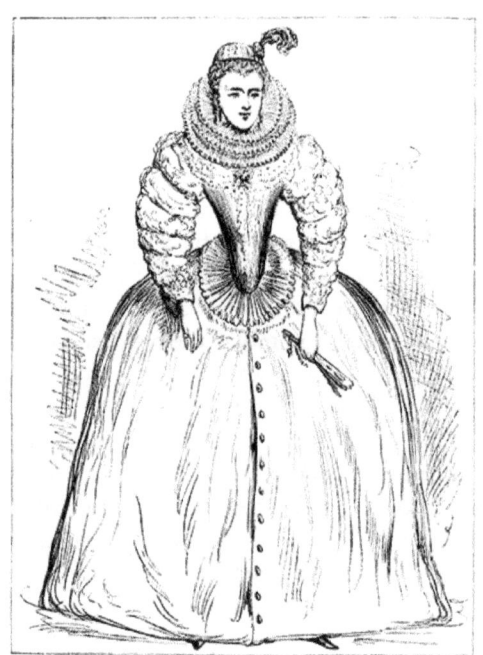

Lady of the Court of Queen Catherine de Medici.

Full Court Dress as worn in France, 1515.

CHAPTER IV.

The *bonnet à canon* and sugarloaf headdress—Headdress of the women of Normandy at the present day—Odd dress of King Louis XI.—Return of Charles VIII. from Naples—A golden time for tailors and milliners—General change of fashion—Costumes of the time of Francis I. of France and Maximilian of Germany—General use of pins in France and England—Masks worn in France—Establishment of the empire of Fashion in France—The puffed or *bouffant* sleeves of the reign of Henry II.—The Bernaise dress—Costume of the unfortunate Marie Stuart—Rich dresses and long slender waists of the period—The tight-lacing of Henry III. of France—The Emperor Joseph of Austria, his edict forbidding the use of stays, and how the ladies regarded it—Queen Catherine de Medici and Queen Elizabeth of England—The severe form of Corsets worn in both France and England—The *corps*—Steel Corset covers of the period—Royal standard of fashionable slenderness—The lawn ruffs of Queen Bess—The art of starching—Voluminous nether-garments worn by the gentlemen of the period—Fashions of the ladies of Venice—Philip Stubs on the ruff—Queen Elizabeth's collection of false hair—Stubs furious at the fashions of ladies—King James and his fondness for dress and fashion—Restrictions and sumptuary laws regarding dress—Side-arms of the period.

FROM about 1380 to some time afterwards headdresses of most singular form of construction were in general wear in fashionable circles. One of these, the *bonnet à canon*, was introduced by Isabel of Bavaria. The "*sugar-loaf*" headdress was also in high esteem, and considered especially becoming and attractive. The accompanying illustration faithfully represents both of these. The latter in a modified form is still worn by the women of Normandy. Throughout the reign of Louis XI. dress continued to be most sumptuous in its character. Velvet was profusely worn, with costly precious stones encircling the trimmings. Sumptuary laws were issued right and left, with a view to the correction of so much extravagance, whilst the king himself wore a battered, shabby old felt cap, with a bordering of leaden figures of the Virgin Mary round it. The rest of his attire was plain and simple to a degree.

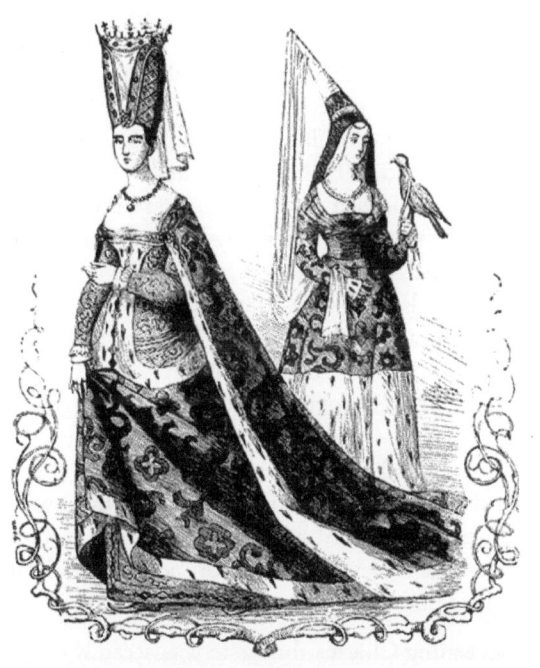

Ladies of Fashion in the Costume of 1380.

Norman Headdress of the Present Day.

Next we see his successor, Charles VIII., returning as a conqueror from Naples, dressed in the first style of Italian fashion. Then came a period of intense activity on the part of milliners and tailors, and a short time sufficed to completely metamorphose the reigning belles of the nation. Smaller, much more becoming and coquettish headdresses were introduced, and a general change of style brought about. Germany participated in the same sudden change of fashion, which lasted until the reign of Francis I. Accompanying illustrations represent a lady of the court of Maximilian I. of Germany, and a lady of the court of Francis I. of France. During his reign pins came into general use both in France and England, although their use had been known to the most ancient races, numerous specimens having been discovered in the excavations of Thebes and other Old World cities. Ladies' masks or visors were also introduced in France at this period, but they did not become general in England until the reign of Queen Elizabeth. It was about this time that France commenced the establishment of her own fashions and invented for herself, and that the ladies of that nation became celebrated for the taste and elegance of their raiment.

On Henry II. succeeding Charles this taste was steadily on the increase. The *bouffant*, or puffed form of sleeve, was introduced, and a very pretty and becoming style of headdress known as the *Bernaise*. The illustration shows a lady wearing this, the feather being a mark of distinction. The dress is made of rich brocade, and the waist exceedingly long (period, 1547.) The right-hand figure represents the unfortunate Marie Stuart arrayed in a court dress of the period, 1559. On the head is a gold coronet; her under-dress is gold brocade, with gold arabesque work over it; the over-dress is velvet, trimmed with ermine; the girdle consisted of costly strings of pearls; the sleeves are of gold-coloured silk, and the puffings are separated from each other by an arrangement of precious stones; the front of the dress is also profusely ornamented in the same manner; the frill or ruff was made from costly lace from Venice or Genoa, and was invented by this very charming but unfortunate lady; the form of the waist is, as will be seen on reference to this illustration, long, and shows by its contour the full influence of the tightly-laced corset beneath the dress, which fits the figure with extraordinary accuracy.

At this time Fashion held such despotic sway throughout the continent of Europe, that the Emperor Joseph of Austria, following out his extraordinary penchant for the passing of edicts, and becoming alarmed at the formidable lures laid out for the capture of mankind by the fair sex, passed a law rigorously forbidding the use of the corset in all nunneries and places where young females were educated; and no less a threat than that of excommunication, and the loss of all the indulgences the Church was capable

of affording, hung over the heads of all those evil-disposed damsels who persisted in a treasonable manner in the practice of confining their waists with such evil instruments as stays. Royal command, like an electric shock, startled the College of Physicians into activity and zeal, and learned dissertations on the crying sin of tight lacing were scattered broadcast amongst the ranks of the benighted and tight-laced ladies of the time, much as the advertisements of cheap furnishing ironmongers are hurled into the West-End omnibuses of our own day.

It is proverbial that gratuitous advice is rarely followed by the recipient. Open defiance was in a very short time bid to the edicts of the emperor and the erudite dissertations of the doctors. The corsets were, if possible, laced tighter than ever, and without anything very particular happening to the world at large in consequence.

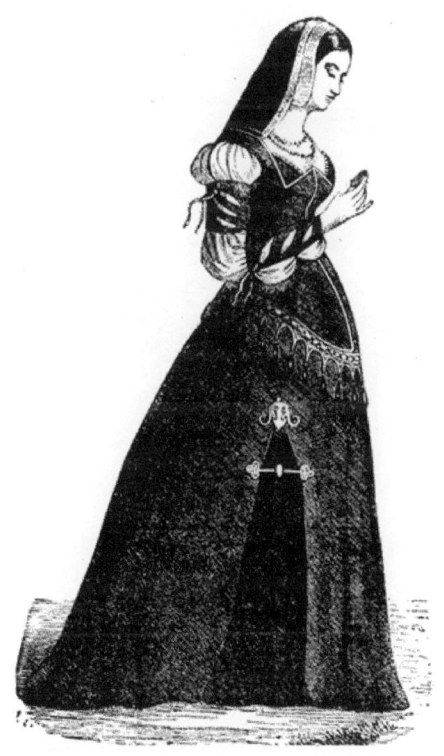

Lady of the Court of Charles VIII., 1560.

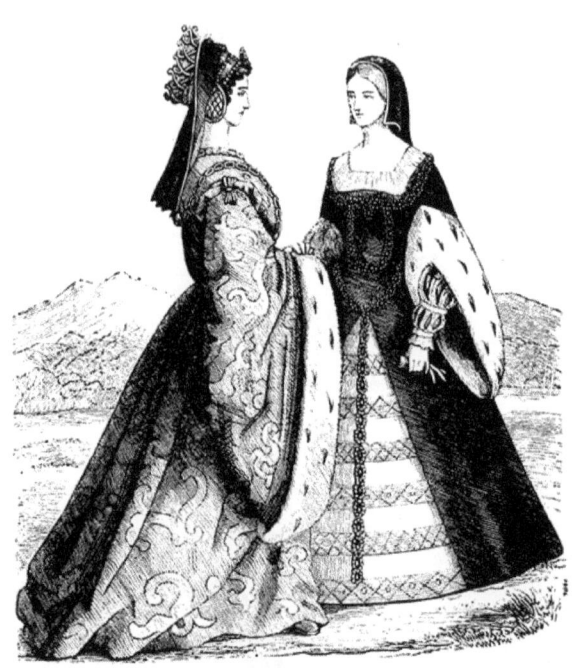

Lady of the Court of Maximilian of Germany and Francis of France.

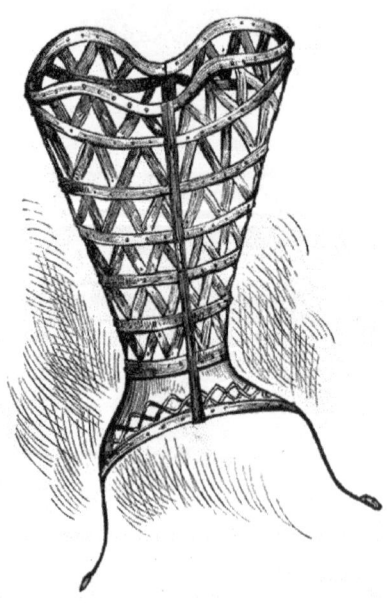

Corset-Cover of Steel Worn in the Time of Catherine de Medici.

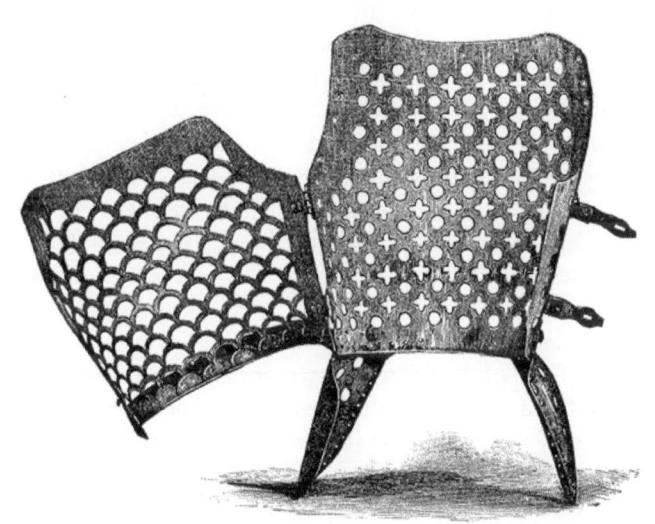

Corset-Cover of Steel worn in the Reign of Queen Elizabeth (Open).

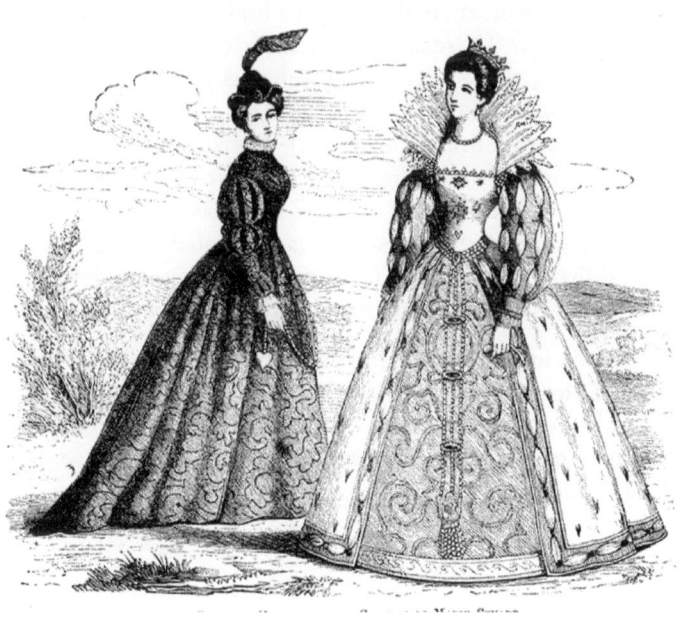

The Bernaise Headdress, and Costume of Marie Stuart.

On Queen Catherine de Medici, who, it will be seen, was a contemporary of Queen Elizabeth of England, assuming the position of power which she so

long maintained at the court of France, costume and fashion became her study, and at no period of the world's history were its laws more tremendously exacting, and the ladies of her court, as well as those in distinguished circles, were compelled to obey them. With her a thick waist was an abomination, and extraordinary tenuity was insisted on, thirteen inches waist measure being the standard of fashionable elegance, and in order that this extreme slenderness might be arrived at she herself invented or introduced an extremely severe and powerful form of the corset, known as the *corps*. It is thus described by a talented French writer:—"This formidable corset was hardened and stiffened in every imaginable way; it descended in a long hard point, and rose stiff and tight to the throat, making the wearers look as if they were imprisoned in a closely-fitting fortress." And in this rigid contrivance the form of the fair wearer was incased, when a system of gradual and determined constriction was followed out until the waist arrived at the required degree of slenderness, as shown in the annexed illustration. Several writers have mentioned the "*steel corsets*" of this period, and assumed that they were used for the purpose of forcibly reducing the size of the waist. In this opinion they were incorrect, as the steel framework in question was simply used to wear over the corset after the waist had been reduced by lacing to the required standard, in order that the dress over it might fit with inflexible and unerring exactness, and that not even a fold might be seen in the faultless stomacher then worn. These corsets (or, more correctly, corset-covers) were constructed of very thin steel plate, which was cut out and wrought into a species of open-work pattern, with a view to giving lightness to them. Numbers of holes were drilled through the flat surfaces between the hollows of the pattern, through which the needle and thread were passed in covering them accurately with velvet, silk, or other rich materials. During the reign of Queen Catherine de Medici, to whom is attributed the invention of these contrivances, they became great favourites, and were much worn, not only at her court, but throughout the greater part of the continent.

They were made in two pieces, opened longitudinally by hinges, and were secured when closed by a sort of *hasp and pin*, much like an ordinary box fastening. At both the front and back of the corsage a long rod or bar of steel projected in a curved direction downwards, and on these bars mainly depended the adjustment of the long peaked body of the dress, and the set of the skirt behind. The illustration at page 71 gives a view of one of those ancient dress-improvers.

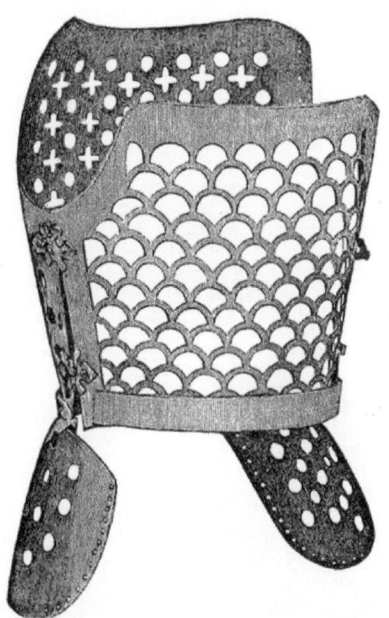

Corset-Cover of Steel worn in the Reign of Queen Elizabeth (Closed).

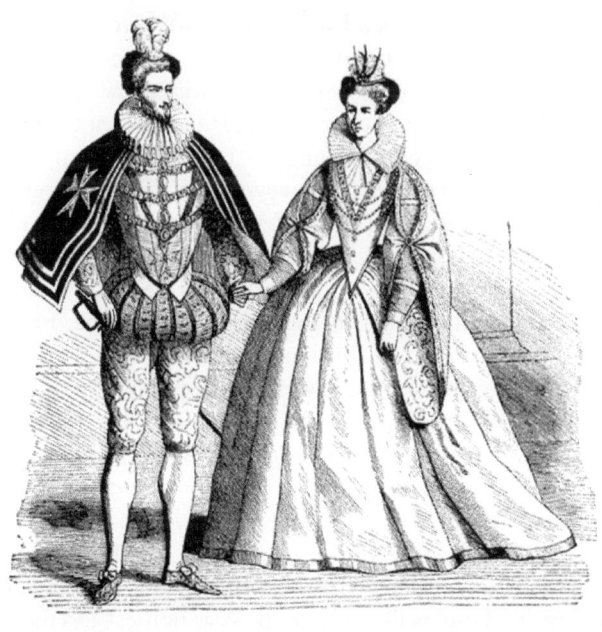

Henry III. of France and the Princess Margaret of Lorraine.

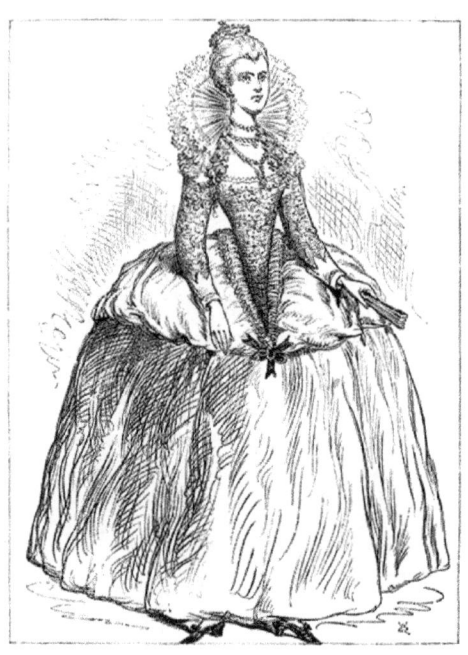

Lady of the Court of Queen Elizabeth.

The votaries of fashion of Queen Elizabeth's court were not slow in imitating in a rough manner the new continental invention, and the illustrations at pages 72 and 76, taken from photographs, will show that, although not precisely alike, the steel corset-covers of England were much in principle like those of France, and the accompanying illustration represents a court lady in one of them. We have no evidence, however, that their use ever became very general in this country, and we find a most powerful and unyielding form of the corset constructed of very stout materials and closely ribbed with whalebone superseding them. This was the *corps* before mentioned, and its use was by no means confined to the ladies of the time, for we find the gentlemen laced in garments of this kind to no ordinary degree of tightness. That this custom prevailed for some very considerable time will be shown by the accompanying illustration, which represents Queen Catherine's son, Henry III. (who was much addicted to the practice of tight lacing), and the Princess Margaret of Lorraine, who was just the style of figure to please his taste, which was ladylike in the extreme. Eardrops in his ears, delicate kid gloves on his hands; hair dyed to the fashionable tint, brushed back under a coquettish little velvet cap, in which waved a white ostrich's feather; hips bolstered and padded out, waist laced in the very tightest and most unyielding of corsets, and feet incased in embroidered satin shoes, Henry was a true son

of his fashionable mother, only lacking her strong will and powerful understanding. England under Elizabeth's reign followed close on the heels of France in the prevailing style of dress. From about the middle of her reign the upper classes of both sexes carried out the custom of tight lacing to an extreme which knew scarcely any bounds. The corsets were so thickly quilted with whalebone, so long and rigid when laced to the figure, that the long pointed stomachers then worn fitted faultlessly well, without a wrinkle, just as did the dresses of the French court over the steel framework before described. The following lines by an old author will give some idea of their unbending character:—

"These privie coats, by art made strong,

 With bones, with paste, with such-like ware,

 Whereby their back and sides grow long,

 And now they harnest gallants are;

 Were they for use against the foe

 Our dames for Amazons might go."

On examining the accompanying illustration representing a lady of the court of Queen Elizabeth, it will be observed that the farthingale, or verdingale, as it is sometimes written, and from which the modern crinoline petticoat is borrowed, serves to give the hips extraordinary width, which, coupled with the frill round the bottom of the stomacher, gave the waist the appearance of remarkable slenderness as well as length. The great size of the frills or ruffs also lent their aid in producing the same effect.

It was in the reign of Elizabeth that the wearing of lawn and cambric commenced in this country; previously even royal personages had been contented with fine holland as a material for their ruffs. When Queen Bess had her first lawn ruffs there was no one in England who could starch them, and she procured some Dutch women to perform the operation. It is said that her first starcher was the wife of her coachman, Guillan. Some years later one Mistress Dinghen Vauden Plasse, the wife of a Flemish knight, established herself in London as a professed starcher. She also gave lessons in the art, and many ladies sent their daughters and kinswomen to learn of her. Her terms were five pounds for the starching and twenty shillings additional for learning to "seeth" the starch. Saffron was used with it to impart to it a yellow colour which was much admired. The gentlemen of the period indulged in nether garments so puffed out and voluminous that the legislature was compelled to take the matter in hand. We read of "a man who,

having been brought before the judges for infringing the law made against these extensive articles of clothing, pleaded the convenience of his pockets as an excuse for his misdemeanour. They appeared, indeed, to have answered to him the purposes both of wardrobe and linen cupboard, for from their ample recesses he drew forth the following articles—viz., a pair of sheets, two tablecloths, ten napkins, four shirts, a brush, a glass, a comb, besides nightcaps and other useful things; his defence being—'Your worship may understand that because I have no safer storehouse these pockets do serve me for a roome to lay up my goodes in; and though it be a strait prison, yet it is big enough for them.'" His discharge was granted, and his clever defence well laughed at.

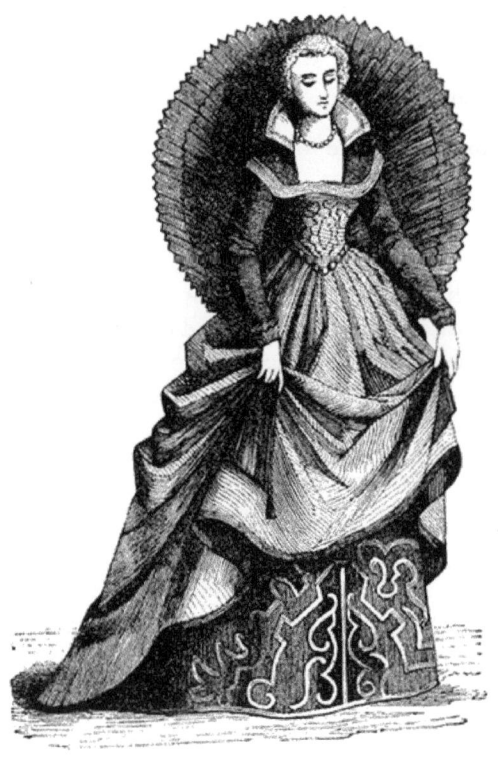

A Venetian Lady of Fashion, 1560.

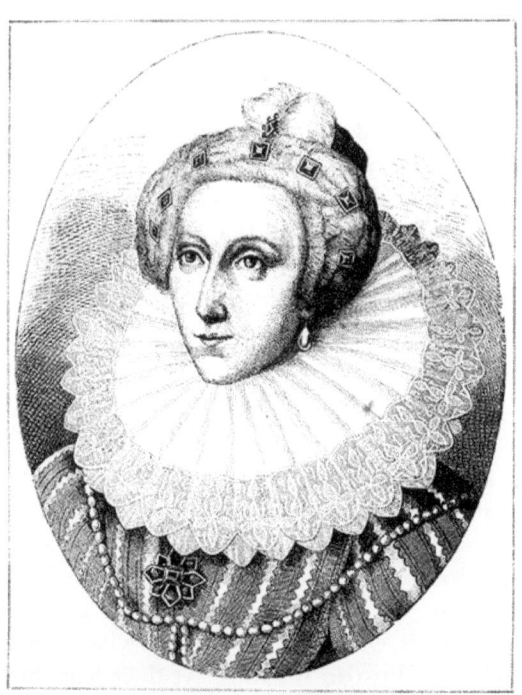

Queen Elizabeth.

The Venetian ladies appear to have been fully aware of the reducing effect of frills and ruffs on the apparent size of waist of the wearer, and they were, as the annexed illustration will show, worn of extraordinary dimensions; but the front of the figure was, of course, only displayed, and on this all the decoration and ornamentation that extravagant taste could lavish was bestowed. The Elizabethan ruff, large as it was, bore no comparison with this, and was worn as shown in the accompanying portrait of the "Virgin Queen," who indulged in numerous artifices for heightening her personal attractions. The ruffs and frills of the period so excited the ire of Philip Stubs, a citizen of London, that in his work, dated 1585, he thus launches out against them in the quaint language of the time:—

"The women there vse great ruffes and neckerchers of holland, laune, cameruke, and such clothe as the greatest threed shall not be so big as the least haire that is, and lest they should fall downe they are smeared and starched in the devil's liquor, I mean starche; after that dried with great diligence, streaked, patted, and rubbed very nicely, and so applied to their goodly necks, and withal vnderpropped with supportasses (as I told you before), the stately arches of pride; beyond all this they have a further fetche, nothing inferiour to the rest, as namely—three or four degrees of minor ruffes placed *gradation*, one beneath another, and al under the mayster

deuilruffe. The skirtes, then, of these great ruffes are long and wide, every way pleated and crested full curiously, God wot! Then, last of all, they are either clogged with gold, silver, or silk lace of stately price, wrought all over with needleworke, speckeled and sparkeled here and there with the sunne, the mone, the starres, and many other antiques strange to beholde. Some are wrought with open worke downe to the midst of the ruffe, and further, some with close worke, some wyth purled lace so cloied, and other gewgaws so pestered, as the ruffe is the least parte of itselfe. Sometimes they are pinned upp to their eares, sometimes they are suffered to hange over theyr shoulders, like windemill sailes fluttering in the winde; and thus every one pleaseth her selfe in her foolish devises."

In the matter of false hair her majesty Queen Elizabeth was a perfect connoisseur, having, so it is said, eighty changes of various kinds always on hand. The fashionable ladies, too, turned their attention to artificial adornment of that kind with no ordinary energy, and poor old Stubs appears almost beside himself with indignation on the subject, and thus writes about it:—"The hair must of force be curled, frisled, and crisped, laid out in wreaths and borders from one ear to another. And, lest it should fall down, it is underpropped with forks, wires, and I cannot tell what, rather like grim, stern monsters than chaste Christian matrons. At their hair thus wreathed and crested are hanged bugles, ouches, rings, gold and silver glasses, and such like childish gewgaws." The fashion of painting the face also calls down his furious condemnation, and the dresses come in for a fair share of his vituperation, and their length is evidently a source of excessive exasperation. We give his opinions in his own odd, scolding words:—

"Their gownes be no less famous than the rest, for some are of silke, some velvet, some of grograine, some of taffatie, some of scarlet, and some of fine cloth of x., xx., or xl. shillings a yarde. But if the whole gowne be not silke or velvet, then the same shall be layd with lace two or three fingers broade all over the gowne, or els the most parte, or if not so (as lace is not fine enough sometimes), then it must bee garded with great gardes of velvet, every yard fower or sixe fingers broad at the least, and edged with costly lace, and as these gownes be of divers and sundry colours, so are they of divers fashions—chaunging with the moone—for some be of new fashion, some of the olde, some of thys fashion, and some of that; some with sleeves hanging downe to their skirtes, trailing on the ground, and cast over their shoulders like cows' tailes; some have sleeves muche shorter, cut vp the arme and poincted with silke ribbons, very gallantly tied with true love's knottes (for so they call them); some have capes reachyng downe to the midest of their backes, faced with velvet, or els with some wrought silke taffatie at the least, and fringed about very bravely (and to shut vp all in a worde), some are peerled and rinsled downe the backe wonderfully, with more knackes than I

can declare. Then have they petticoates of the beste clothe that can be bought, and of the fayrest dye that can be made. And sometimes they are not of clothe neither, for that is thought too base, but of scarlet grograine, taffatie, silke, and such like, fringed about the skirtes with silke fringe of chaungeable colour, but whiche is more vayne, of whatsoever their petticoates be yet must they have kirtles (for so they call them), either of silke, velvett, grogaraine, taffatie, satten, or scarlet, bordered with gardes, lace, fringe, and I cannot tell what besides."

History fails to enlighten us as to whether the irascible Stubs was blessed with a stylish wife and a large family of fashionable daughters, but we rather incline to the belief that he must have been a confirmed old bachelor, as we cannot find that he was ever placed in a lunatic asylum, a fate which would inevitably have befallen him if the fashions of the time had been brought within the sphere of his own dwelling. It is somewhat singular that, writing, as he did, in the most violent manner against almost every article of personal adornment, and every artifice of fashionable life, the then universal and extreme use of the corset should have escaped censure at his hands.

King James, who succeeded Elizabeth, manifested an inordinate fondness for dress. We read that—"Not only his courtiers, but all the youthful portion of his subjects, were infected in a like manner, and the attire of a fashionable gentleman in those days could scarcely have been exceeded in fantastic device and profuse decoration. The hair was long and flowing, falling upon the shoulders; the hat, made of silk, velvet, or beaver (the latter being most esteemed), was high-crowned, narrow-brimmed, and steeple-shaped. It was occasionally covered with gold and silver embroidery, a lofty plume of feathers, and a hatband sparkling with gems being frequently worn with it. It was customary to dye the beard of various colours, according to the fancy of the wearer, and its shape also differed with his profession. The most effeminate fashion at this time was that of wearing jewelled rings in the ears, which was common among the upper and middle ranks. Gems were also suspended to ribbons round the neck, while the long 'lovelock' of hair so carefully cherished under the left ear was adorned with roses of ribbons, and even real flowers. The ruff had already been reduced by order of Queen Elizabeth, who enacted that when reaching beyond 'a nayle of a yeard in depth' it should be clipped. In the early part of her reign the doublet and hose had attained a preposterous size, especially the nether garments, which were stuffed and bolstered with wool and hair to such an extent that Strutt tells us, on the authority of one of the Harleian manuscripts, that a scaffold was erected round the interior of the Parliament House for the accommodation of such members as wore them! This was taken down in the eighth year of Elizabeth's reign, when this ridiculous fashion was laid aside. The doublet was afterwards reduced in size, but still so hard-quilted that the wearer could

not stoop to the ground, and was incased as in a coat of mail. In shape it was like a waistcoat, with a large cape, and either close or very wide sleeves. These latter were termed *Danish*. A cloak of the richest materials, embroidered in gold or silver, and faced with foxskin, lambskin, or sable, was buttoned over the left shoulder. None, however, under the rank of an earl were permitted to indulge in sable facings. The hose were either of woven silk, velvet, or damask; the garters were worn externally below the knee, made of gold, silver, or velvet, and trimmed with a deep gold fringe. Red silk stockings, parti-coloured gaiters, and even 'cross gartering' to represent the Scotch tartan, were frequently seen. The shoes of this period were cork-soled, and elevated their wearers at least two or three inches from the ground. They were composed of velvet of various colours, worked in the precious metals, and if fastened with strings, immense roses of ribbon were attached to them, variously ornamented, and frequently of great value, as may be seen in Howe's continuation of Stowe's Chronicle, where he tells us 'men of rank wear garters and shoe-roses of more than five pounds price.' The dress of a gentleman was not considered perfect without a dagger and rapier. The former was worn at the back, and was highly ornamented. The latter having superseded, about the middle of Elizabeth's reign, the heavy two-handed sword, previously used in England, was, indeed, chiefly worn as an ornament, the hilt and scabbard being always profusely decorated."

CHAPTER V.

Strange freaks of Louise de Lorraine—One of her adventures—Her dress at a royal *fête*—Marie de Medici—The distended dresses of her time—Hair-powder—Costume *à la enfant*—Escapade of the young Louis—Low dresses of the period—The court of Louis XIV. of France—High heels, slender waists, and fancy costumes—The Siamese dress—Charles I. of England—Patches introduced—Elaborate costumes of the period—Puritanism, its effect on the fashions—Fashions in Cromwell's time, and the general prevalence of the practice of tight-lacing—The ladies of Augsburg described by Hoechstetterus.

LITTLE change appears to have taken place in the prevailing fashions of England for some considerable time after this period. In France two opposing influences sprang up. Henry III., as we have seen, was the slave of fashion, and mainly occupied his time in devising some new and extravagant article of raiment. His wife, Louise de Lorraine, on the other hand, although exceedingly handsome, was of a gloomy, stern, and ascetic disposition, dressing more like a nun than the wife of so gay a husband. She caused numerous sumptuary laws to be framed, in order to, if possible, reduce the style of ladies' dress to a standard nearer her own; and the following anecdote will serve to show the petty spirit in which her powers were sought to be exercised.

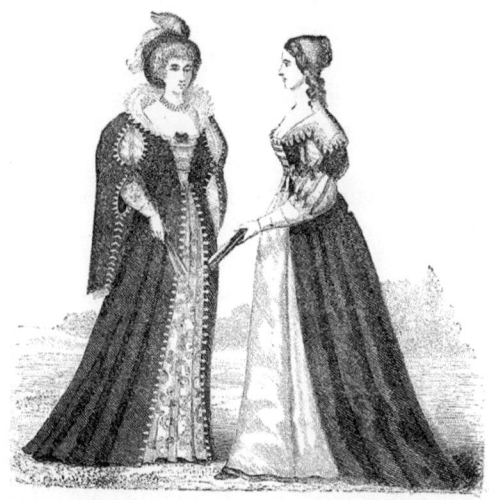

Court Dress during the Boyhood of Louis XIII.

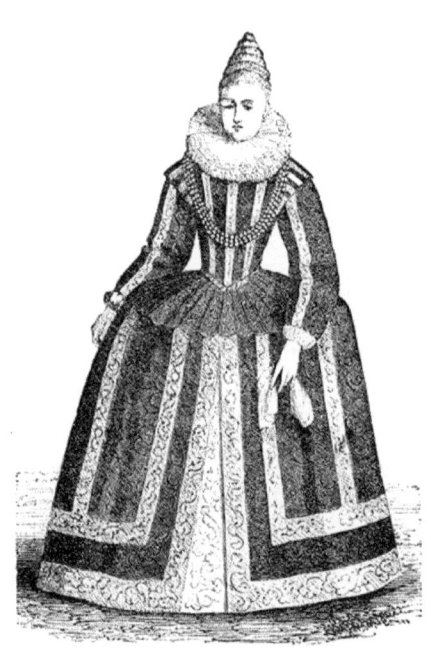

Marie de Medici.

A writer on her life says, "She was accustomed to go out on foot with but a single attendant, both habited plainly in some woollen fabric, and one day, on entering a mercer's shop in the Rue St. Denis, she encountered the wife of a president tricked out superbly in the latest fashions of the day. The subject did not recognise the sovereign, who inquired her name, and received for answer that she was called 'La Présidente de M.,' the information being given curtly, and with the additional remark, 'to satisfy your curiosity.' To this the queen replied, 'But, Madame la Présidente, you are very smart for a person of your condition.' Still the interrogator was not recognised, and Madame la Présidente, with that pertness so characteristic of ordinary womankind, replied, 'At any rate, you did not pay for my smartness.' Scarcely was this retort completed when it dawned upon the speaker that it was the queen who had been putting these posing questions, and then a scene followed of contrite apology on the one hand, and remonstrance on the frivolity of smart attire on the other, both very easy to imagine." With all this pretended simplicity and humility, Queen Louise, on certain occasions, indulged in the most lavish display of her personal attractions. It is related of her that on the marriage of her sister Margaret, she attended a magnificent *fête* given at the Hôtel de Bourbon, and made her appearance in the saloon or grand ball-room as the leader of twelve beautiful young ladies, arrayed as

Naiads. The queen wore a dress of silver cloth, with a tunic of flesh-coloured and silver *crêpes* over it; on her head she wore a splendid ornament, composed of triangles of diamonds, rubies, and various other gems and precious stones. Still the king was the acknowledged leader of fashion, which the queen did all in her power to suppress, except when it suited her royal caprice to astonish the world with her own elegance.

Henry IV. appears to have had no especial inclination for matters relating to fashion, and the world wagged much as it pleased so far as he was concerned. On his marrying, however, his second wife, Marie de Medici, another ardent supporter of all that was splendid, sumptuous, and magnificent was found. His first wife, indeed, Marguerite de Valois, had strong fashionable proclivities, but she was utterly eclipsed by the new star, whose portrait is the subject of the accompanying illustration, in which it will be seen that the wide hips and distended form of dress accompany the long and narrow waist. This style of costume remained popular, as did hair-powder, which was introduced in consequence of the grey locks of Henry IV., until the boy-king Louis XIII., who was placed under the control and regency of his mother, caused by his juvenile appearance a marked change in the fashions of the time. The men shaved off their whiskers and beards, and the ladies brushed back their hair *à l'enfant*, and as about this time Marie showed strong indications of a tendency towards portliness, the hoops were discarded; and short waists, laced to an extreme degree of tightness, long trailing skirts, and very high-heeled shoes were introduced. The dresses of this period of sudden change were worn excessively low, and it is said of young Louis that he was so alarmed, enraged, and astonished at the sight of the white shoulders of a lady of high position that he threw a glass of wine over them, and precipitately quitted the scene of his discomfiture. The annexed illustration shows the style of dress after the changes above referred to.

The next noteworthy changes we shall see taking place during the reign of Charles I. in England and Louis XIV. of France. The court of the *Grand Monarque* was one of extraordinary pomp and magnificence; flowing ringlets, shoes with heels of extraordinary height, and waists of extreme slenderness were the rage. Fancy costumes were also much affected. The accompanying illustration represents a lady and gentleman of the period equipped for the *chase*, but of what it would be difficult to say, unless butterflies were considered in the category of game. The so-called Siamese dress, which became so generally popular, was worn first during the reign of Louis XIV. Many of these dresses were extremely rich and elegant; one is described as having the tunic or upper-skirt composed of scarlet silk with brocaded gold flowers. The under-skirt was of green and gold, with frills of exquisite work from the elbow to the wrist. The accompanying illustration represents a court lady dressed in this style, and that which follows it a fancy dress of the same

period. It was in this reign that the coloured and ornamented clocks to ladies' stockings first made their appearance. Patches for the face were first worn in England during the reign of Charles, although they continued in use for a great number of years, and the following satirical lines were written by an old author regarding them and one of their wearers:—

"Your homely face, Flippanta, you disguise

 With patches numerous as Argus' eyes;

 I own that patching's requisite for you,

 For more we're pleased the less your face we view;

 Yet I advise, since my advice you ask,

 Wear but one patch, and be that patch a mask."

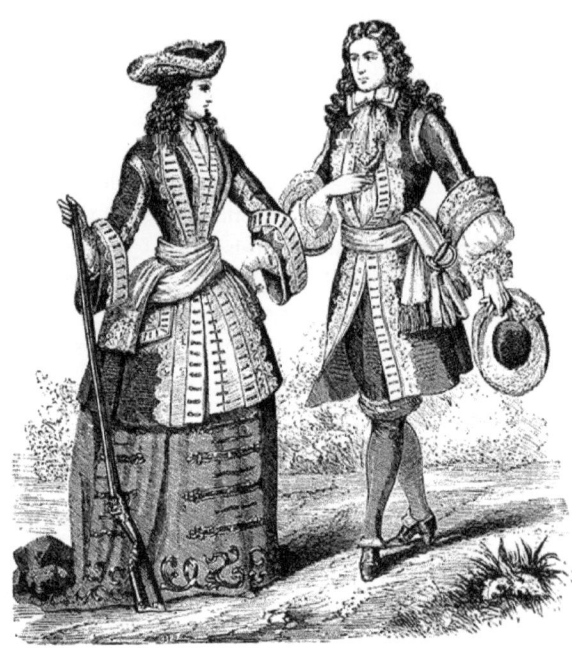

Fancy Costumes of the Time of Louis XIV.

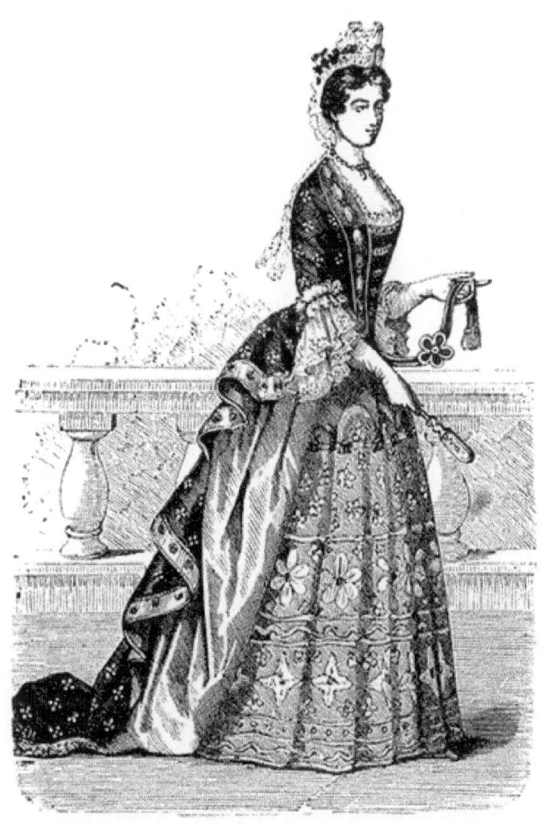

Siamese Dress worn at the Court of Louis XIV.

The fashions set by the court of Louis were eagerly seized on by the whole of Europe. The flowing curls, lace cuffs, and profuse embroidery in use at the court of Charles of England were all borrowed from France, but the general licence and laxity of the period for some short time showed itself in the dress of the ladies, whilst fickleness and love of change, accompanied by thoughtless luxury and profusion, prevailed. The following complaint of a lady's serving-man, dated 1631, will show that the Puritans were not without reason in condemning the extravagances of the time:—

"Here is a catalogue as tedious as a taylor's bill of all the devices which I am commanded to provide (*videlicet*):—

"Chains, coronets, pendants, bracelets, and earrings,
 Pins, girdles, spangles, embroidaries, and rings,

Shadomes, rebatacs, ribbands, ruffs, cuffs, falls,
Scarfs, feathers, fans, maskes, muffes, laces, cauls,
Thin tiffanies, cobweb lawn, and fardingales,
Sweet sals, vyles, wimples, glasses, crumping pins,
Pots of ointment, combs, with poking-sticks, and bodkins,
Coyfes, gorgets, fringes, rowels, fillets, and hair laces,
Silks, damasks, velvets, tinsels, cloth of gold,
Of tissues with colours a hundredfold,
But in her tyres so new-fangled is she
That which doth with her humour now agree,
To-morrow she dislikes; now doth she swear
That a losse body is the neatest weare,
But ere an hour be gone she will protest
A strait gown graces her proportion best.

"Now calls she for a boisterous fardingale,
 Then to her hips she'll have her garments fall.
 Now doth she praise a sleeve that's long and wide,
 Yet by and by that fashion doth deride;
 Sometimes she applauds a pavement-sweeping train,
 And presently dispraiseth it again;
 Now she commands a shallow band so small
 That it may seem scarce any band at all;
 But now a new fancy doth she reele,
 And calls for one as big as a coach-wheele;
 She'll weare a flowry coronet to-day,
 The symbol of her beauty's sad decay;
 To-morrow she a waving plume will try,
 The emblem of all female levitie;
 Now in her hat, then in her hair is drest,

Now of all fashions she thinks change the best."

On Puritanism becoming general the style of dress adopted by the so-called "Roundheads," as a contrast to that of the hated "Cavaliers," was stiff, prim, and formal to a degree; and during Cromwell's sway as Protector, small waists, stiff corsets, and very tight lacing again became the fashion; and Bulwer, who writes in 1653, in speaking of the young ladies of his day, says, "They strive all they possibly can by streight lacing themselves to attain unto a wand-like smallness of waist, never thinking themselves fine enough until they can span their waists." The annexed illustration, adapted by us from his work, *The Artificial Changeling*, represents a young lady who has achieved the desired tenuity. He also quotes from Hoechstetterus, who in his description of "*Auspurge*, the metropolis of *Swevia*," 1653 (meaning Augsburg, the capital of *Suabia*), "They are," saith he, describing the virgins of Auspurge, "slender, streight laced, with '*demisse*' (sloping) shoulders, lest being grosse and well made they should be thought to have too athletique bodies." So throughout the length and breadth of Europe the use of tightly-laced corsets remained general.

Young English Lady of Fashion, 1653.

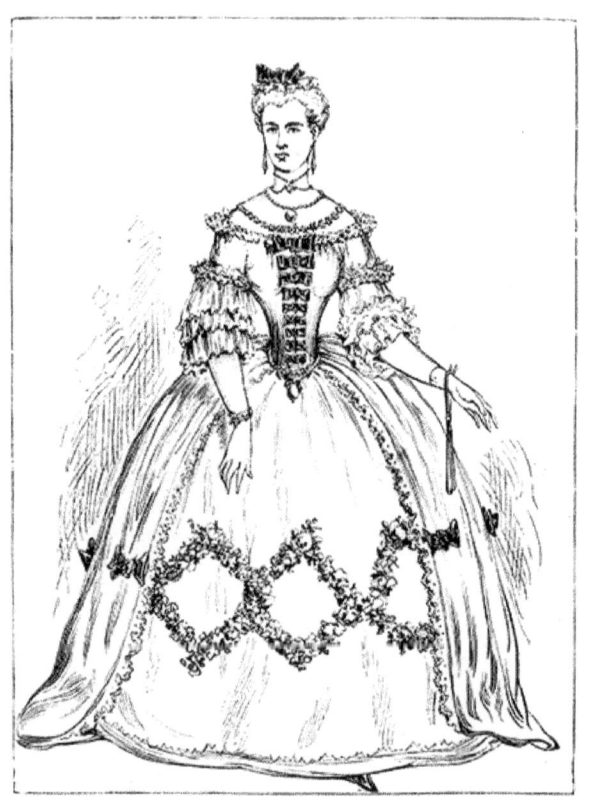

Fancy Dress worn in the Reign of Louis XV.

CHAPTER VI.

Fashion during the reign of Louis XV.—Costumes *à la* Watteau—An army of barbers—The fashions of England during the reign of Queen Anne—The diminutive waist and enormous hoop of her day—The farthingale: letters in the *Guardian* protesting against its use—Fashion in 1713—Low dresses, tight stays, and short skirts: letters relating to—Correspondence touching the fashions of that period from the *Guardian*—Accomplishments of a lady's-maid—Writings of Gay and Ben Jonson—Their remarks on the "*bodice*" and "*stays.*"

AT the death of Louis XIV. and the accession of his successor, Louis XV., in 1715, fashions ran into wonderful extremes and caprices. Hoops became the rage, as did patches, paint, and marvellously high-heeled shoes. The artistic skill of Watteau in depicting costume and devising the attributes of the favourite fancy dresses of the time, led to their adoption among the votaries of fashion. Shepherds who owned no sheep were tricked out in satins, laces, and ribbons, and tripped it daintily hand in hand with the exquisitely-dressed, slender-waisted shepherdesses we see reproduced in Dresden china and the accompanying illustration. Guitars tinkled beneath the trees of many a grove in the pleasure-grounds of the fine old châteaux of France; fruit strewed on the ground, costly wines in massive flagons, groups of gay gallants and charming belles, such as the accompanying illustration represents, engaged in love-making, music and flirtation, make up the scene on which Watteau loved most to dwell, and which King Louis' gay subjects were not slow in performing to the life, and the happy age of the poet appeared all but realised:—

"There was once a golden time

When the world was in its prime—

When every day was holiday,

And every shepherd learned to love."

To carry out the everyday life of this dream world, no small amount of sacrifice and labour was needed, and we are informed that over twelve hundred hairdressers were in full occupation in Paris alone, frizzing, curling, and arranging in a thousand and one fantastical ways, hours being needed to perfect the head-gear of a lady of *ton*. For the prevailing fashions of England we must step back a few years, and glance at the latter portion of the reign

of Queen Anne, at which time we find the diminutive size of the waist in marked contrast to the enormous dimensions of the hoop or farthingale, which reached such a formidable size that numerous remonstrances appeared in the journals of the day relative to it. The following letter complaining of the grievance appeared in the *Guardian* of July 22, 1713:—

> "MR. GUARDIAN,—Your predecessor, the *Spectator*, endeavoured, but in vain, to improve the charms of the fair sex by exposing their dress whenever it launched into extremities. Amongst the rest the great petticoat came under his consideration, but in contradiction to whatever he has said, they still resolutely persist in this fashion. The form of their bottom is not, I confess, altogether the same, for whereas before it was one of an orbicular make, they now look as if they were pressed so that they seem to deny access to any part but the middle. Many are the inconveniences that accrue to her majesty's loving subjects from the said petticoats, as hurting men's shins, sweeping down the ware of industrious females in the street, &c. I saw a young lady fall down the other day, and, believe me, sir, she very much resembled an overturned bell without a clapper. Many other disasters I could tell you of that befall themselves as well as others by means of this unwieldy garment. I wish, Mr. Guardian, you would join with me in showing your dislike of such a monstrous fashion, and I hope, when the ladies see this, the opinion of two of the wisest men in England, they will be convinced of their folly.

"I am, sir, your daily reader and admirer,

<p style="text-align:right">TOM PAIN."</p>

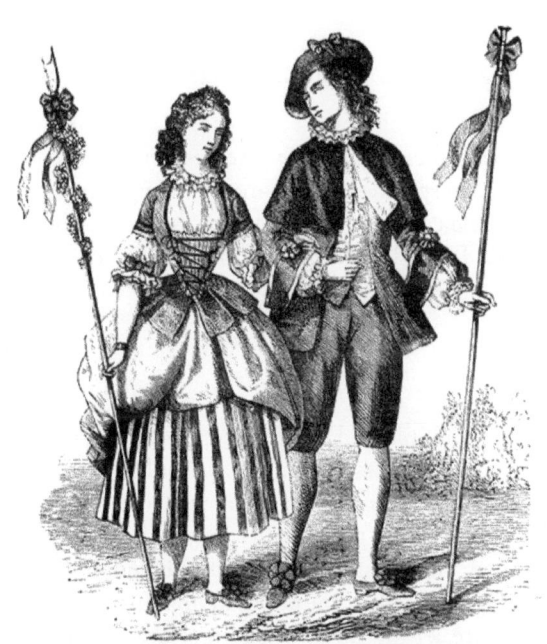

Costumes after Watteau.

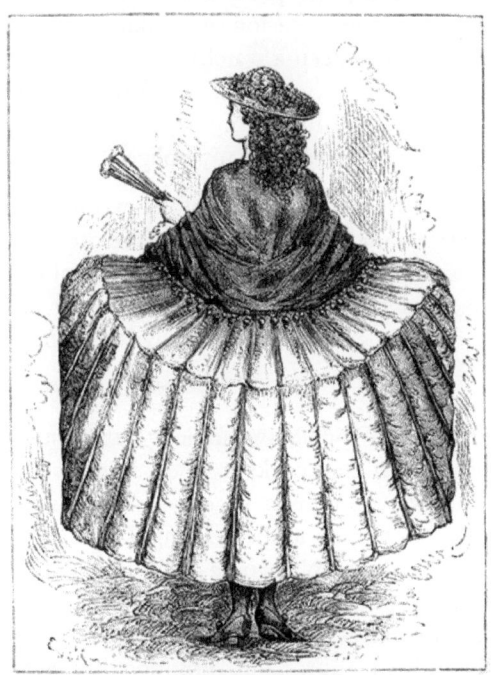

Crinoline in 1713.

The accompanying illustration will show that these remonstrances were not without cause.

The fashion of wearing extremely low dresses, with particularly short skirts, also led to much correspondence and many strong remarks, which are duly commented on by the editor of the *Guardian*, assisted by his "*good old lady*," as he calls her, "the Lady Lizard." Thus he writes on the subject under discussion:—

"*Editorial letter.*

"GUARDIAN, *July 16, 1713.*

"I am very well pleased with this approbation of my good sisters. I must confess I have always looked on the 'tucker' to be the *decus et tutamen*, the ornament and defence of the female neck. My good old lady, the Lady Lizard, condemned this fashion from the beginning, and has observed to me, with some concern, that her sex at the same time they are letting down their stays are tucking up their petticoats, which grow shorter and shorter every day. The leg discovers itself in proportion with the neck, but I may possibly take another occasion of handling this extremity, it being my design to keep a watchful eye over every part of the female sex, and to regulate them from head to foot. In the meantime I shall fill up my paper with a letter which comes to me from another of my obliged correspondents."

That these very low dresses were not alone worn in the house and at assemblies, but were also occasionally seen on the promenades, is shown by the following satirical appeal to the editor of the journal from which we have just been quoting, and the accompanying illustration represents the too-fascinating style of costume which caused its writer so much concern:—

"*Wednesday, August 12, 1713.*

"Notwithstanding your grave advice to the fair sex not to lay the beauties of their necks so open, I find they mind you so little that we young men are as much in danger as ever. Yesterday, about seven in the evening, I took a walk with a gentleman, just come to town, in a public walk. We had not walked above two rounds when the spark on a sudden pretended weariness, and as I importuned him to stay longer he turned short, and, pointing out a celebrated beauty, 'What,' said he, 'do you think I am made of, that I

could bear the sight of such snowy beauties? She is intolerably handsome.' Upon this we parted, and I resolved to take a little more air in the garden, yet avoid the danger, by casting my eyes downwards; but, to my unspeakable surprise, discovered in the same fair creature the finest ankle and prettiest foot that ever fancy imagined. If the petticoats as well as the stays thus diminish, what shall we do, dear Mentor? It is neither safe to look at the head nor the feet of the charmer. Whither shall we direct our eyes? I need not trouble you with my description of her, but I beg you would consider that your wards are frail and mortal.

"Your most obedient servant,

"EPERNECTISES."

Low Bodies and Curtailed Crinoline.

There is no source, perhaps, from which a clearer view of the fashions of this period, and mode of thought then entertained concerning them, could be obtained than the antiquated journal we have just quoted from. The opinions

therein expressed, and the system of reasoning adopted by some of the contributors to its columns, are so singularly quaint that we cannot resist giving the reader the benefit of them. The happy vein of philosophy possessed by the writer of the following letter must have made the world a mere pleasure-garden, through which he wandered at his own sweet will, "king of the universe:"—

"GUARDIAN, *Friday, May 8th, 1713.*

"When I walk the streets I use the foregoing natural maxim (viz., that he is the true possessor of a thing who enjoys it, and not he that owns it without the enjoyment of it) to convince myself that I have a property in the gay part of all the gilt chariots that I meet, which I regard as amusements designed to delight the eye and the imagination of those kind people who sit in them gaily attired only to please me. I have a real and they only an imaginary pleasure from their exterior embellishments. Upon the same principle I have discovered that I am the natural proprietor of all the diamond necklaces, the crosses and stars, brocades and embroidered cloths which I see at a play or birthnight, as giving more natural delight to the spectator than to those who wear them; and I look on the beaux and ladies as so many paroquets in an aviary, or tulips in a garden, designed purely for my diversion. A gallery of pictures, a cabinet, or library that I have free access to, I think my own. In a word, all that I desire is the use of things, let who will have the keeping of them. By which maxim I am growing one of the richest men in Great Britain, with this difference, that I am not a prey to my own cares or the envy of others."

The reply to the foregoing letter by a lady of fashion, written with a strong dash of satire, is equally curious in its way, as it shows the great importance attached to a pleasing and attractive exterior:—

"*To the Editor of the* GUARDIAN.

"*Tuesday, May 19th, 1713.*

"SIR,—I am a lady of birth and fortune, but never knew till last Thursday that the splendour of my equipage was so beneficial to my country. I will not deny that I have dressed for some years out of the pride of my heart, but am very glad that you have so far settled my conscience in that particular that now I can look upon my vanities as so many virtues, since I am satisfied that my person and garb give

pleasure to my fellow-creatures. I shall not think the three hours' business I usually devote to my toilette below the dignity of a rational soul. I am content to suffer great torment from my stays that my shape may appear graceful to the eyes of others, and often mortify myself with fasting rather than my fatness should give distaste to any man in England. I am making up a rich brocade for the benefit of mankind, and design in a little time to treat the town with a thousand pounds' worth of jewellery. I have ordered my chariot to be newly painted for your use and the world's, and have prevailed upon my husband to present you with a pair of Flanders mares, by driving them every evening round the ring. Gay pendants for my ears, a costly cross for my neck, a diamond of the best water for my finger shall be purchased, at any rate, to enrich you, and I am resolved to be a patriot in every limb. My husband will not scruple to oblige me in these trifles, since I have persuaded him, from your scheme, that pin-money is only so much money set for charitable uses. You see, sir, how expensive you are to me, and I hope you will esteem me accordingly, especially when I assure you that I am, as far as you can see me,

"Entirely yours,

"CLEORA."

The tight lacing and tremendously stiff corsets of the time were also the subjects of satirical remark in some quarters, and were upheld in others, as the two following letters, copied from the *Guardian* of 1713, will show:—

"*Thursday, June 18th, 1713.*

"SIR,—don't know at what nice point you fix the bloom of a young lady, but I am one who can just look back on fifteen. My father dying three years ago left me under the care and direction of my mother, with a fortune not profusely great, yet such as might demand a very handsome settlement if ever proposals of marriage should be offered. My mother, after the usual time of retired mourning was over, was so affectionately indulgent to me as to take me along with her in all her visits, but still, not thinking she gratified my youth enough, permitted me further to go with my relatives to all the publick cheerful but innocent entertainments, where she was too reserved to appear herself. The two first years of my teens were easy, gay, and delightful; every one caressed me, the old ladies told me

how finely I grew, and the young ones were proud of my company; but when the third year had a little advanced, my relations used to tell my mother that pretty Miss Clarey was shot up into a woman. The gentlemen began now not to let their eyes glance over me, and in most places I found myself distinguished, but observed the more I grew into the esteem of their sex, the more I lost the favour of my own; some of those whom I had been familiar with grew cold and indifferent; others mistook by design my meaning, made me speak what I never thought, and so, by degrees, took occasion to break off acquaintance. There were several little insignificant reflections cast upon me, as being a lady of a great many acquaintances, and such like, which I seemed not to take notice of. But my mother coming home about a week ago, told me there was a scandal spread about town by my enemies that would at once ruin me for ever for a beauty. I earnestly intreated her to know it; she refused me, but yesterday it discovered itself. Being in an assembly of gentlemen and ladies, one of the gentlemen, who had been very facetious to several of the ladies, at last turned to me. 'And as for you, madam. Prior has already given us your character:—

"'That air and harmony of shape express,

 Fine by degrees and beautifully less.'

"I perceived immediately a malignant smile display itself in the countenance of some of the ladies, which they seconded with a scornful flutter of the fan, till one of them, unable any longer to contain herself, asked the gentleman if he did not remember what Congreve said about Aurelia, for she thought it mighty pretty. He made no answer, but instantly repeated the verses—

"'The Mulcibers who in the Minories sweat,

 And massive bars on stubborn anvils beat,

 Deformed themselves, yet forge those stays of steel,

 Which arm Aurelia with a shape to kill.'

"This was no sooner over but it was easily discernable what an ill-natured satisfaction most of the company took, and the more pleasure they showed by dwelling upon the two last lines, the more they increased my trouble and confusion. And now, sir, after this tedious account, what would you advise me to? Is there no way to be cleared of these malicious calumnies? What is beauty worth that makes the possessed thus unhappy? Why was Nature so lavish of her gifts to me as to make her kindness prove a cruelty? They tell me my shape is delicate, my eyes sparkling, my lips I know not what, my cheeks, forsooth, adorned with a just mixture of the rose and lillie; but I wish this face was barely not disagreeable, this voice harsh and unharmonious, these limbs only not deformed, and then perhaps I might live easie and unmolested, and neither raise love and admiration in the men, nor scandal and hatred in the women.

"Your very humble servant,

"CLARINA."

"*Editor's Reply to Letter of Thursday, June 18th, 1713.*

"The best answer I can make my fair correspondent is, that she ought to comfort herself with this consideration, that those who talk thus of her know it is false, but wish to make others believe it is true. 'Tis not they think you deformed, but are vexed that they themselves were not so nicely framed. If you will take an old man's advice, laugh and not be concerned at them; they have attained what they endeavoured if they make you uneasie, for it is envy that has made them. I would not have you with your shape one fiftieth part of an inch disproportioned, nor desire your face might be impoverished with the ruin of half a feature, though numbers of remaining beauties might make the loss insensible; but take courage, go into the brightest assemblies, and the world will quickly confess it to be scandal. Thus Plato, hearing it was asserted by some persons that he was a very bad man—'I shall take care,' said he, 'to live so that nobody will believe them.'"

The milliners and lady's-maids of the time were expected to fully understand all matters relating to the training of the figure.

A writer of this period, in speaking of the requisite accomplishments of a mantua-maker, says—"She must know how to hide all the defects in the

proportions of the body, and must be able to mould the shape by the stays so as to preserve the intestines, that while she corrects the body she may not interfere with the pleasures of the palate."

Some difference of opinion has existed as to the period at which the word "stays" was first used to indicate an article of dress of the nature of the corset or bodice. It is evident that the term must have been perfectly familiar long anterior to 1713, as constant use is made of it in the letters we have just given. Gay, who wrote about 1720, also avails himself of it in *The Toilette*—

"I own her taper form is made to please,

 Yet if you saw her unconfined by *stays*!"

The word "boddice," or "bodice," was not unfrequently spelt *bodies* by old authors, amongst whom may be mentioned Ben Jonson, who wrote about 1600, and mentions

"The whalebone man

 That quilts the *bodies* I have leave to span."

CHAPTER VII.

General use of the word "stays" after 1600 in England—Costume of the court of Louis XVI.—Dress in 1776—The formidable stays and severe constriction then had recourse to—The stays drawn by Hogarth—Dress during the French revolutionary period—Short waists and long trains—Writings of Buchan—*Jumpers* and "*Garibaldis*"—Return to the old practice of tight-lacing—Training of figures: backboards and stocks—Medical evidence in favour of stays—Fashion in the reign of George III.—Stays worn habitually by gentlemen—General use of Corsets for boys on the Continent—The officers of Gustavus Adolphus—The use of the Corset for youths: a letter from a gentleman on the subject of—Evidence regarding the wearing of Corsets by gentlemen of the present day—Remarks on the changes of fashion—The term "Crinoline" not new—Crinoline among the South Sea Islanders—Remarks of Madame La Sante on Crinoline and slender waists—Abstinence from food as an assistance to the Corset—Anecdote from the *Traditions of Edinburgh*—The custom of wearing Corsets during sleep, its growing prevalence in schools and private families: letters relating to—The belles of the United States and their "*illusion waists*"—Medical evidence in favour of moderately tight lacing—Letters from ladies who have been subjected to tight-lacing.

FOR some considerable period of time we find stays much more frequently spoken of than corsets in the writings of English authors, but their use continued to be as general and their form of construction just as unyielding as ever, both at home and abroad. The costume worn at the court of Louis XVI., of which the following illustration will give an idea, depended mainly for its completeness on the form of the stays, over which the elaborately-finished body of the dress was made to fit without fold or crease, forming a sort of bodice, which in many instances was sewn on to the figure of the wearer after the stays had been laced to their extreme limit. The towering headdress and immensely wide and distended skirt gave to the figure an additional appearance of tenuity, as we have seen when describing similar contrivances in former times. Most costly laces were used for the sleeves, and the dress itself was often sumptuously brocaded and ornamented with worked wreaths and flowers. High-heeled shoes were not wanting to complete the rather astounding toilet of 1776. For many years before this

time, and, in fact, from the commencement of the eighteenth century, it had been the custom for staymakers, in the absence of any other material strong and unyielding enough to stand the wear and tension brought to bear on their wares, to employ a species of leather known as "*bend*," which was not unlike that used for shoe-soles, and measured very nearly a quarter of an inch in thickness. The stays made from this were very long-waisted, forming a narrow conical case, in the most circumscribed portion of which the waist was closely laced, so that the figure was made upright to a degree. Many of Hogarth's figures, who wear the stays of his time (1730), are erect and remarkably slender-waisted. Such stays as he has drawn are perfectly straight in cut, and are filled with stiffening and bone.

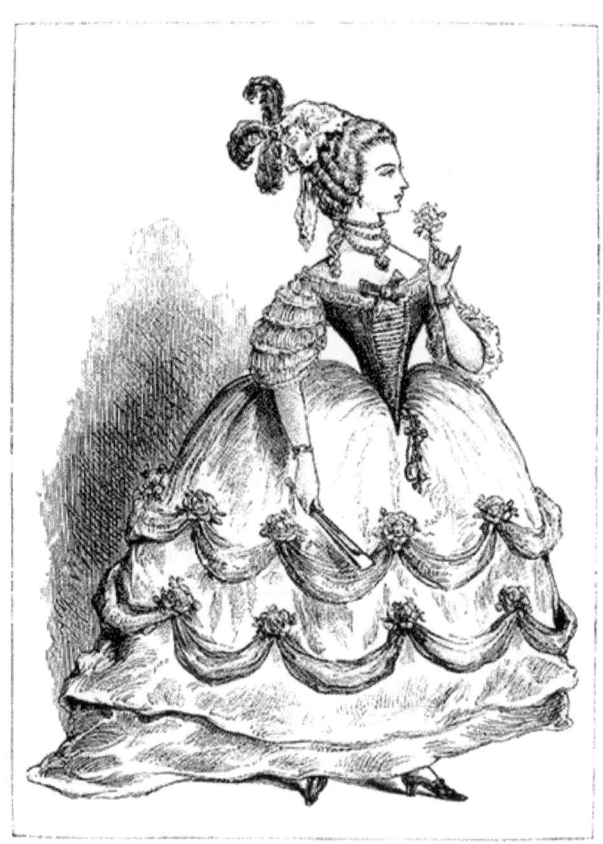

Court Dress of the Reign of Louis XVI.

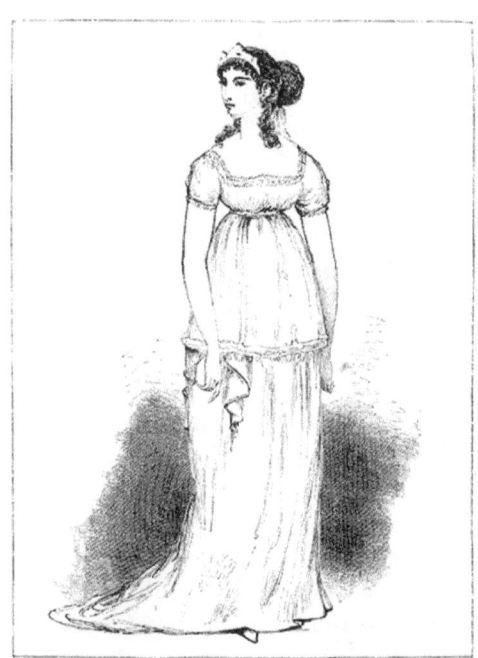

Classic Costume of the French Revolutionary Period.

In 1760 we find a strong disposition manifested to adopt the so-called classic style of costume. During the French revolutionary movement and in the reign of the First Napoleon, the ladies endeavoured to copy the costume of Ancient Greece, and in 1797 were about as successful in their endeavours as young ladies at fancy dress balls usually are in personating mermaids or fairy queens. The annexed illustration represents the classic style of that period. For several years the ladies of England adopted much the same style of costume, and resorted to loose bodies—if bodies they might be called—long trains, and waists so short that they began and ended immediately under the armpits. The following illustration represents a lady of 1806. Buchan, in writing during this short-waisted, long-trained period, congratulates himself and society at large on the fact of "the old strait waistcoats of whalebone," as he styles them, falling into disuse. Not long after this the laws of fashion became unsettled, as they periodically have done for ages, and the lines written by an author who wrote not long after might have been justly applied to the changeable tastes of this transition period:—

"Now a shape in neat stays,

 Now a slattern in jumps,"

these "jumps" being merely loose short jackets, very much like those worn under the name of "*jumpers*" at the present day by shipwrights and some other artificers. The form of the modern "Garibaldi" appears to have been borrowed from this. The reign of relaxation seems to have been of a comparatively short duration indeed, as we see by the remark made by Buchan's son, who edited a new edition of his father's work, *Advice to Mothers*, and an appendix to it:—"Small" (says he) "is the confidence to be placed in the permanent effects of fashion. Had the author lived till the present year (1810), he would have witnessed the fashion of tight lacing revived with a degree of fury and prevailing to an extent which he could form no conception of, and which posterity will not credit. Stays are now composed, not of whalebone, indeed, or hardened leather, but of bars of iron and steel from three to four inches broad, and many of them not less than eighteen in length." The same author informs us that it was by no means uncommon to see "A mother lay her daughter down upon the carpet, and, placing her foot on her back, break half-a-dozen laces in tightening her stays." Those who advocate the use of the corset as being indispensable to the female toilet have much reason on their side when they insist that these temporary freaks of fancy for loose and careless attire only call for infinitely more rigid and severe constriction after they (as they invariably have done) pass away, than if the regular training of the figure had been systematically carried out by the aid of corsets of ordinary power. In a period certainly not much over thirty years, the old-established standard of elegance, "the span," was again established for waist measurement. Strutt, whose work was published in 1796, informs us that in his own time he remembers it to have been said of young women, in proof of the excellence of their shape, that you might *span their waists*, and he also speaks of having seen a singing girl at the Italian Opera whose waist was laced to such an excessive degree of smallness that it was painful to look at her.

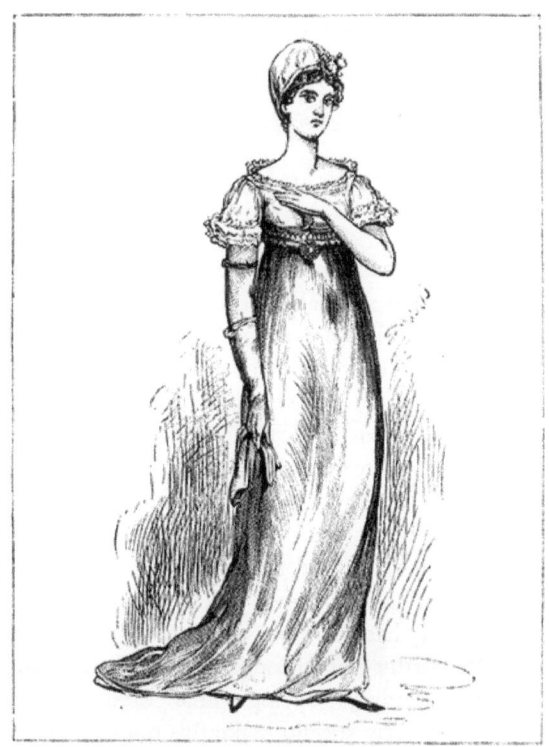

Lady of Fashion, 1806.

Pope, in the *Challenge*, in speaking of the improved charms of a beauty of the court of George II., clearly shows in what high esteem a slender figure was held. As a bit of acceptable news, he says—

"Tell Pickenbourg how *slim* she's grown."

There is abundant evidence to show that no ordinary amount of management and training was had recourse to then, as now, for reducing the waists of those whose figures had been neglected to the required standard of fashionable perfection, and that those who understood the art were somewhat chary in conferring the benefit of it. In a poem entitled the *Bassit Table*, attributed to Lady M. W. Montagu, Similinda, in exposing the ingratitude of a rival beauty, exclaims—

"She owes to me the very charms she wears—
 An awkward thing when first she came to town,

Her shape unfashioned and her face unknown;

I introduced her to the park and plays,

And by my interest *Cozens made her stays.*"

A favour in those days no doubt well worthy of gratitude and due consideration.

About this time it was the custom of some fashionable staymakers to sew a narrow, stiff, curved bar of steel along the upper edge of the stays, which, extending back to the shoulders on each side, effectually kept them back, and rendered the use of shoulder-straps superfluous. The slightest tendency to stoop was at once corrected by the use of the backboard, which was strapped flat against the back of the waist and shoulders, extending up the back of the neck, where a steel ring covered with leather projected to the front and encircled the throat. The young lady of fashion undergoing the then system of boarding-school training enjoyed no bed of roses, especially if unblessed on the score of slenderness. A hard time indeed must an awkward, careless girl have had of it, incased in stiff, tightly-laced stays, backboard on back, and feet in stocks. She simply had to improve or suffer, and probably did both. It is singular and noteworthy that although so many of the older authors give stays the credit of constantly producing spinal curvature, an able writer on the subject of the present day should make this unqualified assertion:—"To some, stays may have been injurious; fewer evils, so far as my experience goes, have arisen from them than from other causes." It is well known that ladies of the eighteenth century did not suffer from spinal disease in the proportion of those of the nineteenth, which might arise in some degree from the system of education; but some highly-educated women of that period were elegant and graceful figures, and it is well known they generally wore stiff stays, though their make, it must be admitted, was less calculated to injure the figure than many of those of the present day.

The author we have just quoted goes on to say—"Mr. Walker, in ridiculing the practice of wearing stays, has chosen a very homely and not very correct illustration of the human figure. 'The uppermost pair of ribs,' says he, 'which lie just at the bottom of the neck, are very short. The next pair are rather longer, the third longer still, and thus they go on increasing in length to the seventh pair, or last true ribs, after which the length diminishes, but without materially contracting the size of the cavity, because the false ribs only go round a part of the body. Hence the chest has a sort of conical shape, or it may be compared to a common beehive, the narrow pointed end being next the neck, and the broad end undermost; the natural form of the chest, in short, is just the reverse of the fashionable shape of the waist; the latter is narrow below and wide above, the former is narrow above and wide below.'

Surely, when the idea struck him, he must have been gazing on a living skeleton, uncovered with muscle. After reading his observations, I took the measure of a well-formed little girl, seven years of age, who had never worn stays, and found the circumference of the bust just below the shoulders one inch and a-half larger than at the lower part of the waist." The views of the author just quoted seem to be borne out by the researches of a French physician of high standing who has paid much attention to the subject. He positively asserts that "*Corsets cannot be charged with causing deviation of the vertebral column.*"

After the period referred to by Buchan's son, when tight-lacing was so rigorously revived, we see no diminution of it, and towards the end of George III.'s reign, gentlemen, as well as ladies, availed themselves of the assistance of the corset-maker. Advertising tailors of the time freely advertised their "Codrington corsets" and "Petersham stiffners" for gentlemen of fashion, much as the "Alexandra corset," or "the Empress's own stay," is brought to the notice of the public at the present day. Soemmering informs us that as long ago as 1760, "It was the fashion in Berlin, and also in Holland a few years before, to apply corsets to children, and many families might be named in which parental fondness selected the handsomest of several boys to put in corsets." In France, Russia, Austria, and Germany, this practice has been decidedly on the increase since that time, and lads intended for the army are treated much after the manner of young ladies, and are almost as tightly laced. It is related of Prince de Ligne and Prince Kaunitz that they were invariably incased in most expensively-made satin corsets, the former wearing black and the latter white. Dr. Doran, in writing of the officers of the far-famed "Lion of the North," Gustavus Adolphus, says, "They were the tightest-laced exquisites of suffering humanity." The worthy doctor, like many others who have written on the subject, inseparably associates the habitual wearing of corsets with extreme suffering; but the gentlemen who, like the ladies, have been subjected to the full discipline of the corset, not only emphatically deny that it has caused them any injury, and, beyond the inconvenience experienced on adopting any new article of attire, little uneasiness, but, on the contrary, maintain that the sensations associated with the confirmed practice of tight-lacing are so agreeable that those who are once addicted to it rarely abandon the practice. The following letter to the *Englishwoman's Magazine* of November, 1867, from a gentleman who was educated in Vienna, will show this:—

> "MADAM,—May I be permitted for once to ask admission to your 'Conversazione,' and to plead as excuse for my intrusion that I am really anxious to indorse your fair correspondent's (Belle's) assertion that it is those who know nothing practically of the corset who are most vociferous in

condemning it? Strong-minded women who have never worn a pair of stays, and gentlemen blinded by hastily-formed prejudice, alike anathematise an article of dress of the good qualities of which they are utterly ignorant, and which consequently they cannot appreciate. On a subject of so much importance as regards comfort (to say nothing of the question of elegance, scarcely less important on a point of feminine costume), no amount of theory will ever weigh very heavily when opposed to practical experience.

"The proof of the pudding is a proverb too true not to be acted on in such a case. To put the matter to actual test, can any of the opponents of the corset honestly state that they have given up stays after having fairly tried them, except in compliance with the persuasions or commands of friends or medical advisers, who seek in the much-abused corset a convenient first cause for an ailment that baffles their skill? 'The Young Lady Herself' (a former correspondent) does not complain of either illness or pain, even after the first few months; while, on the other hand, Staylace, Nora, and Belle bring ample testimony, both of themselves and their schoolfellows, as to the comfort and pleasure of tight lacing. To carry out my first statement as to the truth of Belle's remark, those of the opposite sex who, either from choice or necessity, have adopted this article of attire, are unanimous in its praise; while even among an assemblage of opponents a young lady's elegant figure is universally admired while the cause is denounced. From personal experience, I beg to express a decided and unqualified approval of corsets. I was early sent to school in Austria, where lacing is not considered ridiculous in a gentleman as in England, and I objected in a thoroughly English way when the doctor's wife required me to be laced. I was not allowed any choice, however. A sturdy *mädchen* was stoically deaf to my remonstrances, and speedily laced me up tightly in a fashionable Viennese corset. I presume my impressions were not very different from those of your lady correspondents. I felt ill at ease and awkward, and the daily lacing tighter and tighter produced inconvenience and absolute pain. In a few months, however, I was as anxious as any of my ten or twelve companions to have my corsets laced as tightly as a pair of strong arms could draw them. It is from no feeling of vanity that I have ever since continued to wear them, for, not caring to incur ridicule, I take good

care that my dress shall not betray me, but I am practically convinced of the comfort and pleasantness of tight-lacing, and thoroughly agree with Staylace that the sensation of being tightly laced in an elegant, well-made, tightly-fitting pair of corsets is superb. There is no other word for it. I have dared this avowal because I am thoroughly ashamed of the idle nonsense that is being constantly uttered on this subject in England. The terrors of hysteria, neuralgia, and, above all, consumption, are fearlessly promised to our fair sisters if they dare to disregard preconceived opinions, while, on the other hand, some medical men are beginning slowly to admit that they cannot conscientiously support the extravagant assertions of former days. '*Stay torture*,' '*whalebone vices*,' and 'corset screws' are very terrible and horrifying things upon paper, but when translated into *coutil* or satin they wear a different appearance in the eyes of those most competent to give an opinion. That much perfectly unnecessary discomfort and inconvenience is incurred by the purchasers of ready-made corsets is doubtless true. The waist measure being right, the chest, where undue constriction will naturally produce evil effects, is very generally left to chance. If, then, the wearer suffers, who is to blame but herself?

"The remark echoed by nearly all your correspondents, that ladies have the remedy in their own hands by having their stays made to measure, is too self-evident for me to wish to enlarge upon it; but I do wish to assert and insist that, if a corset allows sufficient room in the chest, the waist may be laced as tightly as the wearer desires without fear of evil consequences; and, further, that the ladies themselves who have given tight-lacing a fair trial, and myself and schoolfellows converted against our will, are the only jury entitled to pronounce authoritatively on the subject, and that the comfortable support and enjoyment afforded by a well-laced corset quite overbalances the theoretical evils that are so confidently prophesied by outsiders.

"WALTER."

Since it has become a custom to send lads from England to the Continent for education, many of them adhere to the use of the corset on their return, and of the use of this article of attire among the rising generation of the gentlemen of this country there can be no doubt; we are informed by one of the leading corset-makers in London that it is by no means unusual to receive

the orders of gentlemen, not for the manufacture of the belts so commonly used in horse-exercise, but veritable corsets, strongly boned, steeled, and made to lace behind in the usual way—not, as the corset-maker assured us, from any feeling of vanity on the part of the wearers, who so arranged their dresses that no one would even suspect that they wore corsets beneath them, but simply because they had become accustomed to tight-lacing, and were fond of it. So it will be seen that the fair sex are not the only corset-wearers.

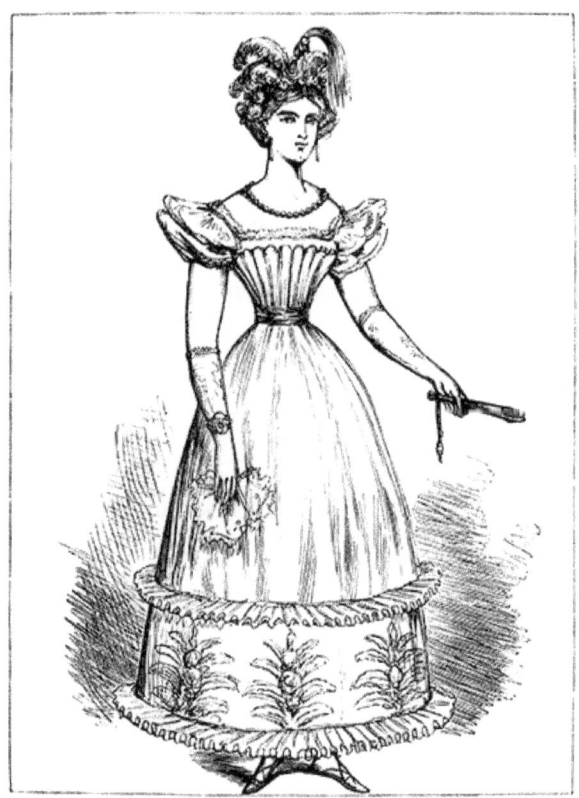

Fashionable Dress in 1824.

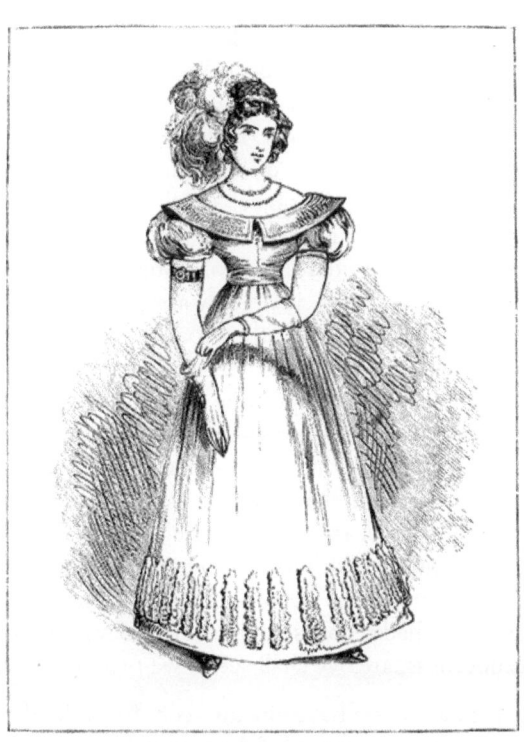

Lady of Fashion, 1827.

During 1824, it will be seen by the accompanying illustration that fashion demanded the contour of the figure should be fully defined, and the absence of any approach to fullness about the skirt below the waist led to the use of very tight stays, in order that there might be some contrast in the outline of the figure. This style of dress, with slight modifications, remained in fashion for several years. In 1827, the dress, as will be seen on reference to the annexed illustration, had changed but little; but three years, or thereabouts, worked a considerable change, and we see, in 1830, sleeves of the most formidable size, hats to match, short skirts, and long slender waists the rage again. A few years later the skirts had assumed a much wider spread; the sleeves of puffed-out pattern were discarded. The waist took its natural position, and was displayed to the best advantage by the expansion of drapery below it, as will be seen on reference to the annexed cut. The term "crinoline" is by no means a new one, and long before the hooped petticoats with which the fashions of the last few years have made us so familiar, the horsehair cloth, so much used for distending the skirts of dresses, was commonly known by that name. It is not our intention here to enter on a description of the almost endless forms which from time to time this adjunct to ladies' dress has assumed. Whether the idea of its construction was first borrowed from

certain savage tribes it is difficult to determine. That a very marked and unmistakable form of it existed amongst the natives of certain of the South Sea Islands at their discovery by the early navigators, the curious cut, representing a native belle, will show, and there is no doubt that, although the dress of the savage is somewhat different in its arrangement from that of the European lady of fashion, the object sought by the use of a wide-spread base to the form is the same. Madame La Sante, in writing on the subject, says—"Every one must allow that the expanding skirts of a dress, springing out immediately below the waist, materially assist by contrast in making the waist look small and slender. It is, therefore, to be hoped that now that crinoline no longer assumes absurd dimensions, it will long continue to hold its ground." The same author, in speaking of the prevailing taste for slender waists, thus writes:—"We have seen that for many hundred years a slender figure has been considered a most attractive female charm, and there is nothing to lead us to suppose that a taste which appears to be implanted in man's very nature will ever cease to render the acquisition of a small waist an object of anxious solicitude with those who have the care of the young." For several years this solicitude has been decidedly on the increase, and many expedients which were had recourse to in ancient days for reducing the waist to exceeding slenderness, are, we shall see as we proceed, in full operation.

A very sparing diet has, as we have already seen, from the days of Terentius, been one great aid to the operation of the corset.

There is a very quaint account to be found in the *Traditions of Edinburgh* bearing on this dieting system. An elderly lady of fashion, who appears to have lived in Scotland during the early part of the last century, was engaged on the formation of the figures of her daughters, stinted meals and tight corsets worn day and night being some of the means made use of; but it is related that a certain cunning and evil-minded cook, whose coarse mind only ran on the pleasure of the appetite, used to creep stealthily in the dead of night to the chamber in which the young ladies slept, unlace their stays, and let them feed heartily on the strictly-prohibited dainties of the pantry; grown rash by impunity, she one night ventured to attempt running the blockade with hot roast goose, but three fatal circumstances combined against the success of the dangerous undertaking. In the first place, the savoury perfume arising from hot roast goose was penetrating to an alarming degree; in the second, the old lady, as ill-luck would have it, happened to be awake, and, worse than all, had no snuff, so smelt goose. The scene which followed the capture of the illicit cargo and the detection of the culprit cook can be much more easily imagined than described.

Lady of Fashion, 1830.

Lady of Fashion, 1837.

The custom of wearing the corset by night as well as by day, above referred to, although partially discontinued for some time, is becoming general again. About the commencement of the last century the custom was much advocated and followed in France, and it is said to reduce and form the figure much more rapidly than any system of lacing by day only could bring about.

A French author of the period referred to says—"Many mothers who have an eye to the main chance, through an excess of zeal, or rather from a strange fear, condemn their daughters to wear corsets night and day, lest the interruption of their use should hinder their project of procuring for them fine waists." That ladies are fully aware of the potent influences of the practice, the following letter to the *Englishwoman's Domestic Magazine* will show:—

> "As several of your correspondents have remarked, the personal experience of those who have for a number of years worn tight-fitting corsets can alone enable a clear and fair judgment to be pronounced upon their use. Happening

to have had what I believe you will admit to be an unusual experience of tight-lacing, I trust you will allow me to tell the story of my younger days. Owing to the absence of my parents in India, I was allowed to attain the age of fourteen before any care was bestowed upon my figure; but their return home fortunately saved me from growing into a clumsy, inelegant girl; for my mamma was so shocked at my appearance that she took the unusual plan of making me sleep in my corset. For the first few weeks I occasionally felt considerable discomfort, owing, in a great measure, to not having worn stays before, and also to their extreme tightness and stiffness. Yet, though I was never allowed to slacken them before retiring to rest, they did not in the least interfere with my sleep, nor produce any ill effects whatever. I may mention that my mamma, fearing that, at so late an age, I should have great difficulty in securing a presentable figure, considered ordinary means insufficient, and consequently had my corsets filled with whalebone and furnished with shoulder-straps, to cure the habit of stooping which I had contracted. The busk, which was nearly inflexible, was not front-fastening, and the lace being secured in a hard knot behind and at the top, effectually prevented any attempt on my part to unloose my stays. Though I have read lately of this plan having been tried with advantage, I believe it is as yet an unusual one, and as the testimony of one who has undergone it without the least injury to health cannot fail to be of value in proving that the much less severe system usually adopted must be even less likely to do harm, I am sure you will do me and your numerous readers the favour of inserting this letter in your most entertaining and valuable magazine. I am delighted to see the friends of the corset muster so strong at the 'Englishwoman's Conversazione.' What is most required, however, are the personal experiences of the ladies themselves, and not mere treatises on tight-lacing by those who, like your correspondent Brisbane, have never tried it.

"MIGNONETTE."

Another correspondent to the same journal (signing herself "Débutante") writes in the number for November, 1867, as follows:—

"Mignonette's case is not an '*unusual*' one. She has just finished her education at a 'West-End school' where the system was strictly enforced. As she entered as a pupil at the age of thirteen and was very slender, she was fitted on her

arrival with a corset, which could be drawn close without the extreme tightness found necessary in Mignonette's case. They did not open in front, and were fastened by the under-governess in such a manner that any attempt to unlace them during the night would be immediately detected at the morning's inspection. After the first week or two she felt no discomfort or pain of any kind, though, as she was still growing, her stays became proportionately tighter, but owing to her figure never being allowed to enlarge during the nine or ten hours of sleep, as is usually the case, this was almost imperceptible."

The Crinoline of a South Sea Islander.

Madame La Sante also refers to the custom as being much more general than is commonly supposed. She says—"Several instances of this system in private families have lately come to my own knowledge, and I am acquainted with more than one fashionable school in the neighbourhood of London where the practice is made a rule of the establishment. Such a method is doubtlessly resorted to from a sense of duty, and those girls who have been subjected to this discipline, and with whom I have had an opportunity of conversing, say that for the first few months the uneasiness by the continued compression was very considerable, but that after a time they became so accustomed to it that they felt reluctant to discontinue the practice." In the United States of America the ladies often possess figures of remarkable slenderness and

elegance, and the term "*illusion*" is not unfrequently applied to a waist of more than ordinary taperness. In a great number of instances the custom above referred to would be found to have mainly contributed to its original formation. The way in which doctors disagree on matters relating to the corset question is most remarkable.

The older writers, as we have seen, launched out in the most sweeping and condemnatory manner against almost every article of becoming or attractive attire. Corsets were most furiously denounced, and had the qualities which were gravely attributed to them been one-thousandth part as deadly as they were represented, the civilised world would long ere this have been utterly depopulated. When we find such diseases and ailments as the following attributed by authors of supposed talent to the use of the corset, we are no longer surprised at remarks and strictures emanating from similar sources meeting with ridicule and derision: "hooping-cough, obliquity of vision, polypus, apoplexy, stoppage of the nose, pains in the eyes, and earache" are all laid at the door of the stays. We are rather surprised that large ears and wooden legs were not added to the category, as they might have been with an equal show of reason. Medical writers of the present day are beginning to take a totally different view of the matter, as the following letter from a surgeon of much experience will show:—

> "My attention has just been directed to an interesting and important discussion in your magazine on the subject of corsets, and I have been urged as a medical man to give my opinion regarding them. Under these circumstances I trust you will allow me to attend the 'Englishwoman's Conversazione' for once, as medical men are supposed to be the great opponents of the corset. It is no doubt true that those medical men who studied for their profession some thirty or forty years ago are still prejudiced against this elegant article of female dress, for stays were very different things even then to what they are now. The medical works, too, which they studied were written years before, and spoke against the buckram and iron stays of the last century. The name 'stays,' however, being still used at the present time, the same odium still attaches to them in the minds of physicians of the old school. But the rising generation of doctors are free from these prejudices, and fairly judge the light and elegant corsets of the present day on their own merits. In short, it is now generally admitted, and I, for one, freely allow, that moderate compression of the waist by well-made corsets is far from being injurious. It is really absurdly illogical for the opponents of the corset to bring

forward quotations from medical writers of the last century, for the animadversions of Soemmering are still quoted. Let us, however, merely look at facts as they at present stand; statistics prove that there are several thousand more women than men in the United Kingdom. A statement in the Registrar-General's Report of a few years since has been brought forward to prove that corsets produce an enormous mortality from consumption, but these would-be benefactors of the fair sex omit to state how many males die from that disease. If there be any preponderance of deaths among women from consumption, the cause may easily be found in the low dress, the thin shoes, and the sedentary occupations in close rooms, without attributing the blame to the corset. Dr. Walshe, in his well-known work on diseases of the lungs, distinctly asserts that corsets cannot be accused of causing consumption. With regard to spinal curvature, a disease which has been connected by some writers with the use of stays, an eminent French physician, speaking of corsets, says—'They cannot be charged with causing deviations of the vertebral column.' Let us, then, hear no more nonsense about the terrible consequences of wearing corsets, at all events till the ladies return to the buckram and iron of our great-grandmothers. Your fair readers may rest assured that what is said against stays at the present day is merely the lingering echo of prejudice, and is quite inapplicable now-a-days to the light and elegant production of the scientific *corsetière*. As a medical man (and not one of the old school) I feel perfectly justified in saying that ladies who are content with a moderate application of the corset may secure that most elegant female charm, a slender waist", without fear of injury to health.

"MEDICUS."

A great number of ladies who, by the systematic use of the corset, have had their waists reduced to the fashionable standard, are to be constantly met in society. The great majority declare that they have in no way suffered in health from the treatment they had been subjected to. *Vide* the following letter from the *Queen* of July 18, 1863:—

"MADAM,—As I have for a long time been a constant reader of the *Lady's Journal*, I venture to ask you if you, or any of your valuable correspondents, will kindly tell me if it is true that small waists are again coming into fashion

generally? I am aware that they cannot be said to have gone out of fashion altogether, for one often sees very slender figures; but I think during the last few years they have been less thought of than formerly. I have heard, however, from several sources, and by the public prints, that they are again to be *La Mode*. Now I fortunately possess a figure which will, I hope, satisfy the demand of fashion in this respect. What is the smallest-sized waist that one can have? Mine is sixteen and a-half inches, and, I have heard, is considered small. I do not believe what is said against the corset, though I admit that if a girl is an invalid, or has a very tender constitution, too sudden a reduction of the waist may be injurious. With a waist which is, I believe, considered small, I can truly say I have good health. If all that was said against the corset were true, how is it so many ladies live to an advanced age? A friend of mine has lately died at the age of eighty-six, who has frequently told me anecdotes of how in her young days she was laced cruelly tight, and at the age of seventeen had a waist fifteen inches. Yet she was eighty-six when she died. I know that it has been so long the habit of public journals to take their example from medical men (who, I contend, are not the best judges in the matter) in running down the corset, and the very legitimate, and, if properly employed, harmless mode of giving a graceful slenderness to the figure, that I can hardly expect that at present you will have courage to take the part of the ladies. But I beg you to be so kind as to tell me what you know of the state of the fashion as regards the length and size of the waist, and whether my waist would be considered small. Also what is the smallest-sized waist known among ladies of fashion. By doing this in an early number you will very much oblige,

"Yours, &c.,

"CONSTANCE."

The foregoing letter was followed on the 25th of the same month by one from another correspondent to the same paper, fully bearing out the truth of the view therein contained, and at the same time showing the system adopted in many of the French finishing schools:—

"MADAM,—As a constant reader of your highly-interesting and valuable paper, I have ventured to reply to a letter under the above heading from your correspondent Constance,

contained in your last week's impression. In reply to her first question, there is little doubt, I think, that slender and long waists will ere long be *la mode*. Ladies of fashion here who are fortunate enough to possess such enviable and graceful attractions, take most especial care by the arrangement of their toilets to show them off to the very best advantage. A waist of sixteen and a-half-inches would, I am of opinion, be considered, for a lady of fair average size and stature, small enough to satisfy even the most exacting of Fashion's votaries. The question as to how small one's waist can be is rather hard to answer, and I am not aware that any standard has yet been laid down on the subject, but an application to any of our fashionable corset-makers for the waist measurement of the smallest sizes made would go far to clear the point up. Many of the corsets worn at our late brilliant assemblies were about the size of your correspondent's, and some few, I have been informed, even less. I beg to testify most fully to the truth of the remarks made by Constance as to the absurdly-exaggerated statements (evidently made by persons utterly ignorant of the whole matter) touching the dreadfully injurious effects of the corset on the female constitution. My own, and a wide range of other experiences, leads me to a totally different conclusion, and I fully believe that, except in cases of confirmed disease or bad constitution, a well-made and nicely-fitting corset inflicts no more injury than a tight pair of gloves. Up to the age of fifteen I was educated at a small provincial school, was suffered to run as nearly wild as could well be, and grew stout, indifferent and careless as to personal appearance, dress, manners, or any of their belongings. Family circumstances and change of fortune at this time led my relatives to the conclusion that my education required a continental finish. Advantage was therefore taken of the protection offered by some friends about to travel, and I was, with well-filled trunks and a great deal of good advice, packed off to a highly-genteel and fashionable establishment for young ladies, situated in the suburbs of Paris. The morning after my arrival I was aroused by the clang of the 'morning bell.' I was in the act of commencing a hurried and by no means an elaborate toilet, when the under-governess, accompanied by a brisk, trim little woman, the bearer of a long cardboard case, made their appearance; corsets of various patterns, as well as silk

laces of most portentous length, were at once produced, and a very short time was allowed to elapse before my experiences in the art and mystery of tight-lacing may be fairly said to have commenced. My dresses were all removed, in order that the waists should be taken in and the make altered; a frock was borrowed for me for the day, and from that hour I was subjected to the strict and rigid system of lacing in force through the whole establishment, no relaxation of its discipline being allowed during the day on any pretence whatever. For the period (nearly three years) I remained as a pupil, I may say that my health was excellent, as was that of the great majority of my young companions in 'bondage,' and on taking my departure I had grown from a clumsy girl to a very smart young lady, and my waist was exactly seven inches less than on the day of my arrival. From Paris I proceeded at once to join my relatives in the island of Mauritius, and on my arrival in the isle sacred to the memories of Paul and Virginia, I found the reign of 'Queen Corset' most arbitrary and absolute, but without in any way that I could discover interfering with either the health or vivacity of her exceedingly attractive and pretty subjects. Before concluding, and whilst on the subject, a few words on the 'front-fastening corset,' now so generally worn, may not come amiss. After a thorough trial I have finally abandoned its use, as being imperfect and faulty in every way, excepting the very doubtful advantage of being a little more quickly put on and off. Split up and open at the front as they are, and only fastening here and there, the whole of the compactness and stability so highly important in this part, of all others, of a corset is all but lost, whilst the ordinary steel busk secures these conditions, to the wearing out of the material of which the corset is composed. The long double-looped round lace used is, I consider, by no means either as neat, secure, or durable as a flat plaited silk lace of good quality. Trusting these remarks and replies may prove such as required by Constance, I beg to subscribe myself,

"FANNY."

Another lady writing to the *Queen* on the same subject in the month of August has a waist under sixteen inches in circumference, as will be seen by the annexed letter, and yet she declares her health to be uninjured:—

"DEAR MADAM,—I have read with interest the letters of Constance and Fanny on the subject of slender waists. It is so much the fashion among medical men to cry down tight-lacing that advocates are very daring who venture to uphold the practice. It has ever been in vogue among our sex, and will, I maintain, always continue so long as elegant figures are admired, for the wearing of corsets produces a grace and slenderness which nature never gives, and if the corset is discontinued or relaxed, the figure at once becomes stout and loose. The dress fits better over a close-laced corset, and the fullness of the skirts, and ease of its folds, are greatly enhanced by the slenderness of the waist. My own waist is under sixteen inches. I have always enjoyed good health. Why, then, if the practice of tight-lacing is not prejudicial to the constitution of all its votaries, should we be debarred from the means of improving our appearance and attaining an elegant and graceful figure? I quite agree with Fanny respecting the front-fastening corset. I consider it objectionable. The figure can never be so neat or slender as in an ordinary well-laced corset. May I inquire what has become of your correspondent Mary Blackbraid? Her partialities for gloves and wigs brought upon her severe remarks from your numerous correspondents. I agree with her in the glove question, and always wear them as much as possible in the house. I find they keep the hands cooler, and in my opinion there is no such finish to the appearance as a well-gloved hand. Where I am now staying the ladies invariably wear them, and I have heard gentlemen express their admiration of the practice. I have worn them to sleep in for some years, and never found any inconvenience. Pardon me trespassing so much on your space, but your interesting paper is the only one open to our defence from the strictures of the over-particular.

"ELIZA."

The following letter from the columns of the *Queen* contains much matter bearing immediately on the subject, and will no doubt be of interest to the reader:—

"MADAM,—I am sure your numerous readers will thank you for your kindness in publishing so impartially the correspondence you have received on the subject of the corset, and as the question is one of great importance, and moreover one on which much difference of opinion seems

to exist, I trust you will continue to give us the benefit of your correspondents' remarks.

"When I read the very *àpropos* letter of Constance, and the excellent letter of Fanny in reply, I was quite prepared to see in your last number some strong expressions of opinion against this most becoming fashion; but I think that they, as well as Eliza, need not be discouraged by the formidable opposition they have met with, and I beg you will afford me space for a few lines, in order to refute the arguments of the anti-corset party, in your valuable journal.

"Much as I, in common with all your readers, delight in reading Mr. Frank Buckland's articles, I really cannot agree with him in his view of the subject. In the first place, I really must question his authority in the matter, for I am convinced that it is only those who have experienced the comfortable support afforded by a well-made corset who are entitled to pronounce their opinion. What can Mr. Buckland, or any one not of the corset-wearing sex, know of the practical operation of this indispensable article of female attire? I will not attempt so arduous a task as that of disproving all that Mr. Combe and his professional brethren have written against tight-lacing; I am even willing to admit that there may be persons so constituted that the attainment of a graceful slenderness would be injurious; but these are the exceptions, not the rule. The remarks of the faculty are founded principally on theory, backed up by an occasional case which might very often be referred to some other cause with equal justice. But who does not know that practice often belies theory, or that theory is frequently at fault? Slender waists have been in fashion for several hundred years, and for the purposes of my argument I will refer to a period thirty or forty years ago. No one then thought of questioning the absolute necessity of attaining a slender figure by the instrumentality of the corset. If, let me ask Mr. Buckland and your other correspondents, theory be true that torture and death are the result, how does it happen not only that there are millions of healthy middle-aged ladies among us now, but that the female population actually exceeds the male? By what wonderful means have they continued to exist and enjoy such perfect health, while such a terrible engine of destruction as the corset was at work

upon their frames? If all that theory said against the corset were true, not a thousand women would now be left alive.

"I cannot avoid troubling you a little further while I descend more into details. Spinal curvature, it is said, is caused by wearing stays. But what kind of stays were they which produced this result, and were no other causes discernible? I think that in every instance it would be found that the stays have been badly made, that they have not been properly laced, or that the busk and materials have not been sufficiently firm.

"In addition to this, girls are too often compelled to maintain an erect position on a form or a music-stool for too long a time during school hours. If the corset is properly made, a young lady may be allowed to lean back in her chair without danger of acquiring lounging habits or injuring her figure. It is to this over-tiring of the muscles that all spinal curvature is attributable, and not to the stays, which, if properly employed, would act as a sure preventative. Again, let me ask any one of the opposite sex who, at any rate at the present day, do not wear stays, whether they have never experienced 'palpitation or flushings,' headaches, and red noses? What right has any one to make these special attendants on small-waisted ladies? There is no more danger of incurring these evils than by a gentleman wearing a hat. Well may the old lady have 'forgotten' these little items in her anecdotes. The comparison between the human frame and a watch is correct in some respects, but it is particularly unhappy in relation to the present subject. The works of a watch are hard and unyielding, and not being possessed of life and power of growing, cannot adapt themselves to their outer case. If you squeeze in the case the works will be broken and put out of order; far different is it with the supple and growing frame of a young girl. If the various organs are prevented from taking a certain form or direction, they will accommodate themselves to any other with perfect ease. Nothing is broken or interfered with in its action. I will, of course, allow that if a fully-grown woman were to attempt to reduce her waist suddenly, respiration and digestion would be stopped; but it is rarely, if ever, that a lady arrives at maturity before she has imbibed sufficient notions of elegance and propriety to induce her to conform to this becoming fashion to some extent. Happy

indeed those who are blessed with mothers who are wise enough to educate their daughters' figures with an eye to their future comfort. The constant discomfort felt by those whose clumsy waists and exuberant forms are a perpetual bugbear to their happiness and advancement should warn mothers of the necessity of looking to the future, and by directing their figures successfully while young, avoid the unsuccessful attempts to force them at an advanced age. One word more on the question. Is a small waist admired by the gentlemen? Mr. Buckland, it seems, has become so imbued with Mr. Combe's ideas against tight-lacing, that he looks upon a slender waist with feelings evidently far from admiration. But is this any reason or authority for concluding that every gentleman of taste is of a like opinion? On the contrary, I think it goes far to prove that it is other than the younger class of gentlemen (for whom, of course, the ladies lay their attractions) who run down the corset. Many times in fashionable assemblies have I heard gentlemen criticising the young ladies in such terms as these;—'What a clumsy figure Miss—— is! it completely spoils her.' 'What a pity Miss—— has not a neater figure!' and so on, and I believe there is not one young man in a thousand who does not admire a graceful slenderness of the waist. What young man cares to dance with girls who resemble casks in form? I have invariably noticed that the girls with the smallest waists are the queens of the ball-room. I have not space to enter into the discussion as to whether the artificial waist is more beautiful than that of the Venus de Medici; on such matters every one forms their own opinions. The waist of the Venus is beautiful for the Venus, but would cease to be so if clothed. I maintain that the comparison is not a good one, as the circumstances are not equal. In other respects, let the ladies, then, not be led to make themselves ungraceful and unattractive by listening to theories which are contradicted by practice, promulgated by persons ignorant, as far as their personal experience goes, of the operation and effect of corsets, and taken up by ladies and gentlemen, not of the youngest, who, like your Country Subscriber, are past the age when the pleasantest excitements of life form topics of interest. Is it not natural that a young lady should be anxious to present a sylph-like form instead of appearing matronly? There are some to whom the words 'tight lacing' suggest immediately what

they are pleased to term 'torture,' 'misery,' &c., but who have never taken the trouble to inquire into the subject, preferring the far easier way of taking for granted that all that has been said against it is true. When such would-be benefactors to the fair sex hear of a sudden death, or see a lady faint at a ball or a theatre, they immediately raise the cry of 'Tight-lacing!' An instance occurred not long ago in which, in a public journal, the sudden death of a young lady was ascribed to this cause, but in a few days afterwards was expressly contradicted in a paragraph of the same paper. Do we never hear of men dying suddenly, or fainting away from overheat? That small waists are the fashion admits of no doubt, for I have myself applied to several fashionable corset-makers in London and the principal fashionable resorts to ascertain whether it be the case. I gather from their information that small waists are most unmistakably the fashion; that there are more corsets made to order under eighteen inches than over that measurement; that the smallest size is usually fifteen inches, though few possess so elegantly small a waist, the majority being about seventeen or eighteen inches; that the ladies are now beginning to see that the front-fastening busk is not so good as the old-fashioned kind, and have their daughters' corsets well boned. Many also prefer shoulder-straps for the stays of growing girls, which keep the chest expanded, and prevent their leaning too much on the busk. If these are not too tight they are very advantageous to the figure, and the upper part of the corset should just fit, but not be tight. A corset made on these principles will cause no injury to health, unless the girl is naturally of a consumptive constitution, in which case no one would think of lacing at all tightly.

"I must apologise for this long letter, but I felt bound to take advantage of the opportunity you afford to discuss this really important question.

"I remain, madam, yours,

"ADMIRER."

CHAPTER VIII.

The elegant figure of the Empress of Austria—Slender waists the fashion in Vienna—The small size of Corsets frequently made in London—Letter from the *Queen* on small waists—Remarks on the portrait of the Empress of Austria in the Exhibition—Diminutive waist of Lady Morton—General remarks on the figure—Remarks on figure-training by the use of stays—Mode of constructing Corsets for growing girls—Tight-lacing abolished by the early use of well-constructed Corsets—Boarding-school discipline and extreme tight-lacing—Letter in praise of tight Corsets—Letter in praise of Crinoline and Corsets—Another letter on boarding-school discipline and figure-training—The waist of fashion contrasted with that of the Venus de Medici—A fashionably-dressed statue—Clumsy figures a serious drawback to young ladies—Letter from a lady, who habitually laces with extreme tightness, in praise of the Corset—Opinions of a young baronet on slender waists; letter from a family man on the same subject.

AS most of our readers will be aware, the much-admired Empress of Austria has been long celebrated for possessing a waist of sixteen inches in circumference, and a friend of ours, who has recently had unusual opportunities afforded for judging of the fashionable world of Vienna, assures us that waists of equal slenderness are by no means uncommon. We are also informed by one of the first West-End corset-makers that sixteen inches is a size not unfrequently made in London. Much valuable and interesting information can be gathered from the following letter from a talented correspondent of the *Queen* a few months ago:—

"CORSETS AND SMALL WAISTS.

"I am a constant reader of the *Queen*, and look forward with anxiety for more of the very interesting letters on the corset question which you are so obliging as to insert in your paper. I know many who take as much pleasure in reading them as myself, for the subject is one on which both health and beauty greatly depend. All who visited the picture-gallery in the Exhibition of 1862 must have seen an exquisitely-painted portrait of the beautiful Empress of Austria, and though it did not show the waist in the most favourable position, some idea may be formed of its elegant slenderness and easy grace. Many were the remarks made

upon it by all classes of critics while I seated myself opposite the picture for a few minutes. I should like any one who maintains that small waists are not generally admired to have taken up the position which I did for half-an-hour, and I am sure she would soon find her opinion unsupported by facts; your correspondents, however, are at fault in supposing that sixteen inches is the smallest waist that the world has almost ever known. Lady Babbage, in her *Collection of Curiosities*, tells us that in a portrait of Lady Morton, in the possession of Lord Dillon, the waist cannot exceed ten or twelve inches in circumference, and at the largest part immediately beneath the armpits not more than twenty-four, and the immense length of the figure seems to give it the appearance of even greater slenderness. Catherine de Medici considered the standard of perfection to be thirteen inches. It is scarcely to be supposed that any lady of the present day possesses such an absurdly small waist as thirteen inches, but I am certain that not a few could be found whose waistband does not exceed fifteen inches and three-quarters or sixteen inches. Much depends on the height and width of the shoulders; narrow shoulders generally admit of a small waist, and many tall women are naturally so slender as to be able to show a small waist with very little lacing. It is needless to remark how much depends on the corset. Your correspondent, A. H. Turnour, says that the long corsets, if well pulled in at the waist, compress one cruelly all the way up, and cause the shoulders to deport themselves awkwardly and stiffly. Now, no corset will be able to do this if constructed as it should be. I believe the great fault to be that when the corset is laced on it is very generally open an inch or so from top to bottom. The consequence of this is, that when the wearer is sitting down, and the pressure on the waist the greatest, the tendency is to pull the less tightly drawn lace at the top of the corset tighter; on changing the posture this does not right itself, and consequently an unnecessary and injurious compression round the chest is experienced. Now, if the corset, when fitted, were so made that it should meet all the way, or at any rate *above* and *below* the waist, when laced on, this evil would be entirely avoided, and absence of compression round the upper part of the chest would give an increased appearance of slenderness to the waist and allow the lungs as much play as the waistbands. There seems

to be an idea that when the corset is made to meet it gives a stiffness to the figure. In the days of buckram this might be the case, but no such effect need be feared from the light and flexible stays of the present day, and the fault which frequently leads to the fear of wearing corsets which do not meet is, that the formation of the waist is not begun early enough. The consequence of this is, that the waist has to be *compressed* into a slender shape after it has been allowed to swell, and the stays are therefore made so as to allow of being laced tighter and tighter. Now I am persuaded that much inconvenience is caused by this practice, which might be entirely avoided by the following simple plan, which I have myself tried with my own daughters, and have found to answer admirably. At the age of seven I had them fitted with stays without much bone and a flexible busk, and these were made to meet from top to bottom when laced, and so as not to exercise the least pressure round the chest and beneath the waist, and only a very *slight* pressure at the waist, just enough to show off the figure and give it a roundness. To prevent the stays from slipping, easy shoulder-straps were added. In front, extending from the top more than half way to the waist, were two sets of lace-holes, by which the stays could be enlarged round the upper part. As my daughters grew, these permitted of my always preventing any undue pressure, but I always laced the stays so as to meet behind. When new ones were required they were made exactly the same size at the waist, but as large round the upper part as the gradual enlargement had made the former pair. They were also of course made a little longer, and the position of the shoulder-straps slightly altered; by these means their figures were directed instead of forced into a slender shape; no inconvenience was felt, and my daughters, I am happy to say, are straight, and enjoy perfect health, while the waist of the eldest is eighteen inches, and that of the youngest seventeen. I am convinced that my plan is the most reasonable one that can be adopted. By this means '*tight-lacing*' will be abolished, for no tight-lacing or compression is required, and the child, being accustomed to the stays from an early age, does not experience any of the inconveniences which are sometimes felt by those who do not adopt them till twelve or fourteen.

"A FORMER CORRESPONDENT (Edinburgh)."

The advisability of training instead of forcing the figure into slenderness is now becoming almost universally admitted by those who have paid any attention to the subject; yet it appears from the following letters, which appeared in the *Englishwoman's Domestic Magazine* of January and February, 1868, that the corset, even when employed at a comparatively late period of life, is capable of reducing the size of the waist in an extraordinary manner, without causing the serious consequences which it has so long been the custom to associate with the practice of tight-lacing.

A Tight-Lacer expresses herself to the following effect:—"Most of your correspondents advocate the early use of the corset as the best means to secure a slender waist. No doubt this is the best and most easy mode, but still I think there are many young ladies who have never worn tight stays who might have small waists even now if they would only give themselves the trouble. I did not commence to lace tightly until I was married, nor should I have done so then had not my husband been so particularly fond of a small waist; but I was determined not to lose one atom of his affection for the sake of a little trouble. I could not bear to think of him liking any one else's figure better than mine, consequently, although my waist measured twenty-three inches, I went and ordered a pair of stays, made very strong and filled with stiff bone, measuring only fourteen inches round the waist. These, with the assistance of my maid, I put on, and managed the first day to lace my waist in to eighteen inches. At night I slept in my corset without loosing the lace in the least. The next day my maid got my waist to seventeen inches, and so on, an inch smaller every day, until she got them to meet. I wore them regularly without ever taking them off, having them tightened afresh every day, as the laces might stretch a little. They did not open in front, so that I could not undo them if I had wanted. For the first few days the pain was very great, but as soon as the stays were laced close, and I had worn them so for a few days, I began to care nothing about it, and in a month or so I would not have taken them off on any account, for I quite enjoyed the sensation, and when I let my husband see me with a dress to fit I was amply repaid for my trouble; and although I am now grown older, and the fresh bloom of youth is gone from my cheek, still my figure remains the same, which is a charm age will not rob me of. I have never had cause to regret the step I took."

Another lady says—"A correspondent in the October number of your magazine states that her waist is only thirteen inches round, but she does not state her height. My waist is only twelve inches round; but then, although I am eighteen years old, I am only four feet five inches in height, so that my waist is never noticed as small; while my elder sister (whose height is five feet eight inches) is considered to have a very nice figure, though her waist is twenty-three inches round. I am glad to have an opportunity of expressing

my opinions on the subject of tight-lacing. I quite agree with those who think it perfectly necessary with the present style of dress (which style I hope is likely to continue). I believe every one admires the effect of tight-lacing, though they may not approve in theory. My father always used to declaim loudly against stays of any kind, so my sister and I were suffered to grow up without any attention being paid to our figures, and with all our clothes made perfectly loose, till my sister was eighteen and I fifteen years old, when papa, after accompanying us to some party, made some remarks on the clumsiness of our figures, and the ill-fitting make of our dresses. Fortunately, it was not too late. Mamma immediately had well-fitting corsets made for us, and as we were both anxious to have small waists we tightened each other's laces four and five times a day for more than a year; now we only tighten them (after the morning) when we are going to a party."

As it has been most justly remarked, no description of evidence can be so conclusive as that of those whose daily and hourly experience brings them in contact with the matter under discussion, and we append here a letter from a correspondent to the *Englishwoman's Domestic Magazine* of May, 1867, giving her boarding-school experience in the matter of extreme tight-lacing:—

Nora says—"I venture to trouble you with a few particulars on the subject of 'tight-lacing,' having seen a letter in your March number inviting correspondence on the matter. I was placed at the age of fifteen at a fashionable school in London, and there it was the custom for the waists of the pupils to be reduced one inch per month until they were what the lady principal considered small enough. When I left school at seventeen, my waist measured only thirteen inches, it having been formerly twenty-three inches in circumference. Every morning one of the maids used to come to assist us to dress, and a governess superintended to see that our corsets were drawn as tight as possible. After the first few minutes every morning I felt no pain, and the only ill effects apparently were occasional headaches and loss of appetite. I should be glad if you will inform me if it is possible for girls to have a waist of fashionable size and yet preserve their health. Very few of my fellow-pupils appeared to suffer, except the pain caused by the extreme tightness of the stays. In one case where the girl was stout and largely built, two strong maids were obliged to use their utmost force to make her waist the size ordered by the lady principal—viz., seventeen inches—and though she fainted twice while the stays were being made to meet, she wore them without seeming injury to her health, and before she left school she had a waist measuring only fourteen inches, yet she never suffered a day's illness. Generally all the blame is laid by parents on the principal of the school, but it is often a subject of the greatest rivalry among the girls to see which can get the smallest waist, and often while the servant was drawing in the waist of my friend to the utmost of her strength, the young lady, though being

tightened till she had hardly breath to speak, would urge the maid to pull the stays yet closer, and tell her not to let the lace slip in the least. I think this is a subject which is not sufficiently understood. Though I have always heard tight-lacing condemned, I have never suffered any ill effects myself, and, as a rule, our school was singularly free from illness. By publishing this side of the question in the *Englishwoman's Domestic Magazine* you will greatly oblige."

Cases like the foregoing are most important and remarkable, as they show most indisputably that loss of health is not so inseparably associated with even the most unflinching application of the corset as the world has been led to suppose. It rather appears that although a very considerable amount of inconvenience and uneasiness is experienced by those who are unaccustomed to the reducing and restraining influences of the corset, when adopted at rather a late period of growth, they not only in a short time cease to suffer, but of their own free will continue the practice and become partial to it. Thus writes an Edinburgh lady, who incloses her card, to the *Englishwoman's Domestic Magazine* of March, 1867:—

> "I have been abroad for the last four years, during which I left my daughter at a large and fashionable boarding-school near London. I sent for her home directly I arrived, and, having had no bad accounts of her health during my absence, I expected to see a fresh rosy girl of seventeen come bounding to welcome me. What, then, was my surprise to see a tall, pale young lady glide slowly in with measured gait and languidly embrace me; when she had removed her mantle I understood at once what had been mainly instrumental in metamorphosing my merry romping girl to a pale fashionable belle. Her waist had, during the four years she had been at school, been reduced to such absurdly small dimensions that I could easily have clasped it with my two hands. 'How could you be so foolish,' I exclaimed, 'as to sacrifice your health for the sake of a fashionable figure?' 'Please don't blame me, mamma,' she replied, 'I assure you I would not have voluntarily submitted to the torture I have suffered for all the admiration in the world.' She then told me how the most merciless system of tight-lacing was the rule of the establishment, and how she and her forty or fifty fellow-pupils had been daily imprisoned in vices of whalebone drawn tight by the muscular arms of sturdy waiting-maids, till the fashionable standard of tenuity was attained. The torture at first was, she declared, often intolerable; but all entreaties were vain,

as no relaxation of the cruel laces was allowed during the day under any pretext except decided illness. 'But why did you not complain to me at first?' I inquired. 'As soon as I found to what a system of torture I was condemned,' she replied, 'I wrote a long letter to you describing my sufferings, and praying you to take me away. But the lady principal made it a rule to revise all letters sent by, or received by, the pupils, and when she saw mine she not only refused to let it pass, but punished me severely for rebelling against the discipline of the school.' 'At least you will now obtain relief from your sufferings,' I exclaimed, 'for you shall not go back to that school any more.' On attempting to discontinue the tight-lacing, however, my daughter found that she had been so weakened by the severe pressure of the last four years that her muscles were powerless to support her, and she has therefore been compelled to lace as tight as ever, or nearly so. She says, however, that she does not suffer much inconvenience now, or, indeed, after the first two years—so wonderful is the power of Nature to accommodate herself to circumstances. The mischief is done; her muscles have been, so to speak, murdered, and she must submit for life to be incased in a stiff panoply of whalebone and steel, and all this torture and misery for what?—merely to attract admiration for her small waist. I called on the lady principal of the establishment the next day, and was told that very few ladies objected to their daughters having their figures improved, that small waists were just now as fashionable as ever, and that no young lady could go into good society with a coarse, clumsy waist like a rustic, that she had always given great satisfaction by her system, which she assured me required unremitting perseverance and strictness, owing to the obstinacy of young girls, and the difficulty of making them understand the importance of a good figure. Finding that I could not touch the heart of this female inquisitor, who was so blinded by fashion, I determined to write to you and inform your readers of the system adopted in fashionable boarding-schools, so that if they do not wish their daughters tortured into wasp-waisted invalids they may avoid sending them to schools where the corset-screw is an institution of the establishment."

And on the appearance of her letter it was replied to by another lady, who writes as follows:—

"In reply to the invitation from the lady from Edinburgh to a discussion on the popular system amongst our sex of compression of the waist, when requisite to attain elegance of figure, I beg to say that I am inclined, from the tone of her letter, to consider her an advocate of the system she at first sight appears to condemn. This conviction of mine may arise from my own partiality to the practice of tight-lacing, but the manner in which she puts the question almost inclines me to believe that she is, as a corset-maker, financially interested in the general adoption of the corset-screw. Her account of the whole affair seems so artificial, so made up for a purpose, so to speak, that I, for one, am inclined to totally discredit it. A waist 'easily clasped with two hands.' Ye powers! what perfection! how delightful! I declare that ever since I read that I have worn a pair of stays that I had rejected for being too small for me, as they did not quite meet behind (and I can't bear a pair that I cannot closely lace), and have submitted to an extra amount of muscular exertion from my maid in order to approach, if ever so distantly, the delightful dimensions of two handsful. Then, again, how charmingly she insinuates that if we will only persevere, only submit to a short probationary period of torture, the hated compression (but desired attenuation) will have become a second nature to us, that not only will it not inconvenience us, but possibly we shall be obliged, for comfort's sake itself, to continue the practice. Now, madam, as a part of the present whole of modern dress, every one must admit that a slender waist is a great acquisition, and from my own experience and the experience of several young lady friends similarly addicted to guide me, I beg to pronounce the so-called evils of tight-lacing to be a mere bugbear and so much cant. Every woman has the remedy in her own hands. If she feels the practice to be an injury to her, she can but discontinue it at any time. To me the sensation of being tightly laced in a pair of elegant, well-made, tightly-fitting corsets is superb, and I have never felt any evil to arise therefrom. I rejoice in quite a collection of these much-abused objects—in silk, satin, and coutil of every style and colour—and never feel prouder or happier, so far as matters of the toilette are concerned, than when I survey in myself the fascinating undulations of outline.

"STAYLACE."

Then follows a letter rather calculated to cast doubt on the subject of the sufferings of the young lady whose case has been described, from a lady who, although possessing a small waist, knows nothing of them. Thus she writes:—

> "Please let me join in the all-absorbing discussion you have introduced at the Englishwoman's monthly Conversazione, and let me first thank Staylace for her capital letter. I quite agree with her in suspecting the story of the young lady at the boarding-school to be overdrawn a little. Would the young lady herself oblige us with a description of her 'tortures,' as I and several of my friends who follow the present fashion of small waists are curious to know something of them, having never experienced these terrible sufferings, though my waistband measures only eighteen inches? The truth is, there are always a number of fussy middle-aged people who (with the best intentions, no doubt) are always abusing some article of female dress. The best of it is, these benevolent individuals are usually of that sex whose costume precludes them from making a personal trial of the articles they condemn. Now it is the crinoline which draws forth their indignant outcries, now the corset, and now the chignon. They know not from their own experience how the crinoline relieves us from the weight of many under-skirts, and prevents them from clinging to us while walking, and they have never felt the comfortable support of a well-made corset. Yet they decry the use of the first as unaccountable, and of the second as suicidal. Let me tell them, however, that the ladies themselves judge from practice and not from theory, and if the opponents of the corset require proof of this, let me remind them that compression of the waist has been more or less universal throughout the civilised world for three or four centuries, in spite of reams of paper and gallons of printing-ink. I may add that, for my own part, I have always laced tightly, and have always enjoyed good health. Allow me to recommend ladies to have their corsets made to measure, and if they do not feel they suffer any inconvenience, they may certainly take the example of your clever correspondent Staylace, and look upon the outcry as a 'bugbear and so much cant.'
>
> <div align="right">"BELLE."</div>

Thus called on, the young lady herself writes and confirms, as it will be seen, the statements of others, that the late use of the corset is the main source of

pain on its first adoption; and the statement she makes that her waist is so much admired that she sometimes forgets the pain passed through in attaining it, coupled with the confession that she is not in ill-health, gives her letter strong significance. Here it is in its integrity:—

> "In last month's number of your valuable magazine you were kind enough to publish a letter from my mamma on the subject of tight-lacing, and as your correspondent Staylace says she is inclined to think the whole story made up for a purpose, mamma has requested me to write and confirm what she stated in her letter. It seems wonderful to me how your correspondent can lace so tightly and never feel any inconvenience. It may be, very likely, owing to her having begun very young. In my case I can only say I suffered sometimes perfect torture from my stays, especially after dinner, not that I ate heartily, for that I found impossible, even if we had been allowed to do so by our schoolmistress, who considered it unladylike. The great difference between your correspondent Staylace and myself seems to be that she was incased in corsets at an early age, and thus became gradually accustomed to tight-lacing, while I did not wear them till I went to school at fourteen, and I did not wear them voluntarily. Of course it is impossible to say whether I underwent greater pressure than she has. I think I must have done so, for my waist had grown large before it was subjected to the lacing, and had to be reduced to its present tenuity, whereas, if she began stays earlier, that would have prevented her figure from growing so large. Perhaps Staylace will be so kind as to say whether she began stays early, or at any rate before fourteen, and what is the size of her waist and her height? One reason why she does not feel any inconvenience from tight corsets may be that, when she feels disposed, she may loosen them, and thus prevent any pain from coming on. But when I was at school I was not allowed to loosen them in the least, however much they distressed me, so that what was in the morning merely a feeling of irksome pressure, became towards the end of the day a regular torture. I quite admit that slender waists are beautiful—in fact, my own waist is so much admired that I sometimes forget the pain I underwent in attaining it. I am also quite ready to confess I am not in ill-health, though I often feel languid and disinclined for walking out. Nor do I think a girl whose constitution is sound would suffer any injury to her health from moderate

> lacing, but I must beg that you will allow me to declare that when stays are not worn till fourteen years of age, very tight lacing causes absolute torture for the first few months, and it was principally to deter ladies from subjecting their daughters to this pain in similar cases that mamma wrote to you. I am sure any young lady who has (like myself) begun tight-lacing rather late will corroborate what I have said, and I hope some will come forward and do so, now you so kindly give the opportunity."

Much ill-deserved blame has been from time to time cast on the lady principals of fashionable schools for insisting on the strict use of the corset by the young ladies in their charge. The following letter from a schoolmistress of great experience, and another from a young lady who has finished her education at a fashionable boarding-school, will at once serve to show that the measures adopted by the heads of these establishments for the obtainment of elegant figures are in the end fully appreciated by those who have been fortunate enough to profit by them.

> A Schoolmistress Correspondent says—"As a regular subscriber to your valuable magazine, I see you have invited your numerous readers to discuss the subject brought forward by a correspondent in Edinburgh, and as the principal of a large ladies' school in that city, I feel sure you will kindly allow me space to say a few words in reply to her letter. In the first place it must be apparent that your correspondent committed a great mistake in placing her daughter at a fashionable school if she did not wish her to become a fashionable belle, or she should at least have given instructions that her daughter should not have her figure trained in what every one knows is the fashionable style. For my own part I have always paid particular attention to the figures of the young ladies intrusted to my care, and being fully convinced that if the general health is properly attended to, corsets are far from being the dreadfully hurtful things some people imagine. I have never hesitated to employ this most important and elegant article of dress, except in one case where the pupil was of a consumptive tendency, and I was specially requested not to allow her to dress at all tightly. All my pupils enjoy good health, my great secret being regular exercise, a point which is almost always disregarded. It appears from your correspondent's letter that the young lady did not experience any inconvenience after the first two years she was at the school, nor does her

mother say her health was affected. She only complains that she is no longer a 'romping girl.' Now, no young lady of eighteen who expects to move in fashionable society would wish to be thought a romping schoolgirl. With regard to the slight pain in the muscles which the young lady described as 'torture,' this was no doubt caused by her not having been accustomed by degrees to a close-fitting dress before she went to the school. I find that girls who have commenced the use of stays at an early age, and become gradually used to them, do not experience any uneasiness when they are worn tighter at fourteen or fifteen. There can be no doubt that a slender figure is as much admired as ever, and always will be so. The present fashion of short waists is admitted on all hands to be very ugly, and will soon go out. Those girls, then, who have not had their figures properly attended to while growing will be unable to reduce their waists when the fashion changes, whereas, by proper care now, they will be able to adopt the fashion of longer waists without any inconvenience. I trust you will allow us schoolmistresses fair play in this important matter, and insert this, or part of it, in your magazine."

Mignon says—"DEAR MRS. ENGLISHWOMAN,—I beg—I pray—that you will not close your delightful Conversazione to the tight-lacing question: it is an absorbing one; hundreds, thousands of your young lady readers are deeply interested in this matter, and the subscribers to your excellent magazine are increasing daily, to my own knowledge, by reason of this interesting controversy; pray wait a little, and you will see how the tight-lacers and their gentlemen admirers will rally round the banner that has been unfurled. There is an attempt being made to introduce the hideous fashion of the 'Empire,' as it is called. Why should we, who have been disciplined at home and at school, and laced tighter and tighter month after month, until our waists have become 'small by degrees and beautifully less,' be expected to hide our figures (which we know are admired) under such atrocious drapery? My stay and dress maker both tell me that it is only the ill-formed and waistless ones that have taken to the fashion; such, of course, are well pleased, and will have no objection to have their waistbands as high as their armpits. Angular and rigid figures have always pretended to sneer at tight-lacers, but any one of them would give half, nay, their whole fortune

> to attain to such small dimensions as some of your correspondents describe. I shall keep my waist where nature has placed it, and where art has improved it, for my own comfort, and because a certain friend has said that he never could survive if it were any larger or shorter. My waist remains just as it was a year and a-half ago, when I left school, where in the course of three years it was by imperceptible degrees laced from twenty to fifteen inches, not only without injury to health but with great satisfaction and comfort to myself."

It has been much the fashion amongst those who have written in condemnation of the use of the corset to contrast the figure of the Venus de Medici with that of a fashionably-dressed lady of the present day; but the comparison is anything but a happy one, as it would be quite as reasonable to insist that because the sandalled and stockingless foot of the lady of Ancient Greece was statuesque in contour when forming a portion of a statue, it should be substituted for the fashionable boot or slipper and silk stocking of the present day. That perfection itself in the sculptor's art when draped in fashionable attire would become supremely grotesque and ridiculous was not long since fully proved by actual experiment. A former contributor to the columns of the *Queen*, who at one time followed the medical profession, felt so convinced of the claims to admiration possessed by the classic order of form, that he obtained a copy of the Greek Slave, and had it draped by a first-rate milliner, who made use of all the modern appliances of the toilet, corset and crinoline included. The result was that dress made a perfect fright of her, and the disappointed experimentalist candidly confessed that he did not like her half as well as he had done. The waist was disproportionately thick, and the whole *tout ensemble* dowdy in the extreme. No fallacy can be greater than to apply the rules of ancient art to modern costume. Thus writes an artist in the *Englishwoman's Domestic Magazine* of September, 1867:—

> "I do not for a moment deny the truth of your artist correspondent's assertions, for I consider, as every one must, that the proportions of the human body are the most beautiful in creation (where all is beautiful and correct), but the great mistake which so many make is this. In civilised countries the body is always clothed; and that clothing, especially of the ladies of European nations, completely hides the contour of the body. The effect of this is to give great clumsiness to the waist when that part of the person is of its natural size. Let any one make a fair and unprejudiced trial, such as this: let him get a statuette of

some celebrated antique, the Venus de Medici or the Greek Slave, and have it dressed in an ordinary dress of the present day, and see what the effect really is. Until fashion, in its ever-changing round, returns to the costume of Ancient Greece or Rome, we can never expect to persuade ladies not to compress their waists merely on the score of beauty; and as several of your correspondents have shown that a moderate compression is not so injurious as some supposed, there is no chance of the corset becoming an obsolete article of female dress. It has been in use for seven or eight hundred years, and now that its form and construction are so much modified and improved, there need be no longer an outcry against it; indeed, outcry has for centuries failed to affect it, though other articles of dress have become in their turn obsolete, a clear proof that there is something more than mere arbitrary fashion in its hold upon the fair sex."

Another gentleman, not an artist, but whose sisters now suffer from all the annoyances consequent on clumsy, ill-trained figures, thus writes to the *Englishwoman's Domestic Magazine* of September, 1867:—

"Though the subject on which I propose to address to you a few observations hardly concerns a man, I hope you will allow me a little space in your excellent journal to express my views upon it. I have been much interested by reading the correspondence on the subject of slender waists, and the means used for attaining them. Now, there can be no doubt that gentlemen admire those figures the most which have attained the greatest slenderness. I think there is no more deplorable sight than a large and clumsy waist; and as nature, without assistance from art, seldom produces a really small waist, I think those mothers and schoolmistresses who insist upon their daughters or pupils between the ages of ten and seventeen wearing well-made corsets, and having them tightly laced, confer upon the young ladies a great benefit, which, though they may not appreciate at the time, they will when they go out into society. Certainly some of your correspondents seem to have fallen into the hands of schoolmistresses thoroughly aware of the advantages of a good figure—a waist that two hands can easily clasp is certainly a marvel. I never had the good fortune to see such a one, yet one of your correspondents assures us that her daughter's was no larger

than that. Nora, too, says that her waist only measured thirteen inches when she left school; this seems to me to be miraculously small. Most gentlemen do not think much about the means used for attaining a fashionable figure, and I should not have done so either if I had not heard it a good deal discussed in my family, where my sisters were never allowed to lace at all tightly, the consequence of which is, that now that they are grown up they have very clumsy figures, much to their regret; but it is too late to alter them now. As doctors seem to think that the dangers of tight-lacing have been much exaggerated, and as I know many ladies with very slender waists enjoying quite as good health as their more strongly built sisters, I would urge upon all who wish to have good figures not to be deterred by alarmists from endeavouring gradually to attain an elegant shape."

It is most remarkable that, notwithstanding the number of letters which have been published casting condemnation and ridicule on those who wear corsets, not one can we discover containing the personal experiences of those who have been anything but temporary sufferers from even their extreme use, whilst such letters as the following, which appeared in the *Englishwoman's Domestic Magazine* of August, 1867, are of a nature to lead to the conclusion that unless the germs of disease of some kind are rooted in the system, a well-made and perfectly-fitting corset may be worn with impunity, even when habitually laced with considerable tightness. The lady thus gives her own experiences and those of her daughters:—

"From the absence of any correspondence on the all-important topic of tight-lacing in your August number, I very much fear that the subject has come to an end. If so, many other subscribers besides myself will be very sorry for it. I cannot tell you what pleasure it gave me to see the sentiments that were expressed by so many who, like myself, are addicted to the practice of tight-lacing, and as for many years I have been in the habit of lacing extremely tight, I trust that you will allow me, by inserting this or part of it, to make known that I have never suffered any pain or illness from it. In the days when I was a schoolgirl, stays were worn much stiffer and higher than the flimsy things now used, and were, besides, provided with shoulder-straps, so that to be very tightly incased in them was a much more serious affair than at the present day. But, nevertheless, I remember our governess would insist on the greatest

possible amount of constriction being used, and always twice a day our stays were tightened still more. A great amount of exercise was inculcated, which perhaps did away with any ill effects this extreme tight-lacing might have occasioned, but while at school I imbibed a liking for the practice, and have ever since insisted on my maid lacing me as tightly as she possibly can. I quite agree with Staylace in saying that to be tightly laced in a pair of tight-fitting stays is a most superb sensation. My two daughters, aged respectively sixteen and eighteen, are brought up in the same way, and would not consider themselves properly dressed unless their stays were drawn together. They can bear me out in my favourable opinion of tight-lacing, and their good health speaks volumes in its praise. I hope, madam, you will kindly insert this letter in your valuable and largely-circulated magazine."

Fairholt remarks, in speaking of the discipline observed in schools during the reign of George III.—"It was the fashion to educate girls in stiffness of manner at all public schools, and particularly to cultivate a fall of the shoulders and an upright set of the bust. The top of the steel stay busk had a long stocking-needle attached to it to prevent girls from spoiling their shape by stooping too much over their needlework. This I have heard from a lady since dead who had often felt these gentle hints and lamented their disuse."

Many opponents to the use of the corset have strongly urged the somewhat weak argument, that ladies with slender waists are not generally admired by the gentlemen. That question has been ably dealt with in one or two of the preceding letters from ladies, and it is but fair to them that the opinions of both the young and old of the male sex (candidly communicated to the columns of the *Englishwoman's Domestic Magazine*) should be added to the weight of evidence in favour of almost universal admiration for a slender and well-rounded waist. Thus writes a young baronet in the number for October, 1867:—

"As you have given your readers the benefit of Another Correspondent's excellent letter will you kindly allow another member of the sterner sex to give his opinion on the subject of small waists? Those who have endeavoured to abolish this most becoming fashion have not hesitated to declare that gentlemen do not care for a slender figure, but that, on the contrary, their only feeling on beholding a waist of eighteen inches is one of pity and contempt. Now so far from this being the case, there is not one gentleman in a thousand who is not charmed with the sight. Elderly

> gentlemen, no doubt, may be found who look upon such things as 'vanity and vexation of spirit;' but is it for these that young ladies usually cultivate their charms? There is one suggestion I should be glad to make if you will permit me, and that is that all those ladies who possess that most elegant attraction, a slender waist, should not hide it so completely by shawls or loose paletots when on the promenade or in the street. When by good-luck I chance to meet a lady who has the good taste, I may say the kindness, to show her tapering waist by wearing a close-fitting paletot, I not unfrequently turn to admire, and so far from thinking of the means used to obtain the result, I am held spellbound by the beauty of the figure."

That elderly gentlemen are by no means as indifferent to the attractions of elegant slenderness as our young correspondent supposes, will be best shown by a letter from a family man on the subject, communicated to the above journal, November, 1867. He says—

> "I have read with much interest the correspondence on the above subject in the Englishwoman's Conversazione for several months past, having accidentally met with one of the numbers of your magazine in a friend's house, and have since regularly taken it, although not previously a subscriber. As an ardent admirer of small waists in ladies, I wish to record for the satisfaction of those who possess them the fact, which is sometimes disputed, that the pains bestowed in attaining a slender figure are *not* in vain so far as we gentlemen are concerned, and some of us are positively absurd in our excessive admiration of this particular female beauty. Poets and novelists are perpetually introducing heroines with tiny waists and impossible feet, and if they are to portray female loveliness in all its attributes, they could not well omit two *such essential* points, and I take it their ideal is not an unfair criterion of the taste of the public at large. I am delighted to learn from very clear evidence put forward by your many correspondents that 'small waists' are attainable by most ladies at little or no inconvenience, and that those of the clumsier build are willing to suffer a certain amount of pain if necessary in reducing their bulky figures to graceful proportions, and, above all, that this can be done without injury to health, for after all it would be a dearly-purchased charm if health were sacrificed. Some fifteen or twenty years ago, I recollect the

word '*stays*' was uttered as though a certain amount of disgrace attached to the wearer, and '*tight-lacing*' was looked on as a crime; but I am glad to see that a reaction is setting in, and that ladies are not afraid to state openly that 'they lace *very* tightly,' and many of them declare the sensation of being laced as tightly as possible as positively a *pleasurable one*. I may say that personally I feel that every lady of my acquaintance, or with whom I may come in contact, who does so places me under a direct obligation. I will go further than your correspondent, A Young Baronet, and say that whenever I meet a young lady who possesses the charm of a small waist, and has the good taste to wear the tight-fitting dress now fashionable for the promenade, I make it a point to see her pretty figure more than once, and have often gone considerably out of my way to do so. Although married years and years ago, I am still a slave to a '*little waist*,' and I am proud to say my wife humours my whim, and her waist is decidedly a small one. I will, therefore, add my experience to that of others (more competent to give an opinion, having experienced tight-lacing in their own proper persons), and state that she never enjoyed better health than when her waist was the smallest, and I shall be much disappointed if her daughters, when they '*come out*' do not emulate their mother's slender figure. By keeping your Conversazione open to the advocates of tight-lacing, and thoroughly ventilating the subject, you will, in my opinion, confer a benefit on the rising generation of young ladies, whose mammas, in too many instances, are so *prejudiced* against the use of the corset that they permit their daughters to grow up into clumsy, awkward young women, to their own disgust and great detriment in the matrimonial market.

"I am, madam, your obedient servant,

"BENEDICT."

The Fashion of 1865.

CHAPTER IX.

The elegance of dress mainly dependent on the Corset—Fashion and dress of 1865—The short-waisted dresses and trains of 1867—Tight Corsets needed for short waists—Letter on the figure—Description of a peculiar form of Corset worn by some ladies of fashion in France—Proportions of the figure and size of the waist considered—The point at which the waist should be formed—Remarks of the older writers on stays—Corsets and high-heeled shoes denounced—Alarming diseases said to be produced by wearing high-heeled shoes—Mortality amongst the female sex not on the increase—Extraordinary statistics of the Corset trade—The Corset of the present day contrasted with that of the olden time.

WE could very easily add letters enough to occupy the remaining portion of this work, all incontestably proving that slender waists *are*, notwithstanding that which some few writers have urged to the contrary, held in high esteem by the great majority of the sterner sex.

Without the aid of the corset, it has been very fairly argued, no dress of the present day could be worn, unless its fair possessor was willing to submit to the withering contempt of merciless society. The annexed illustration represents a lady dressed in the fashion of the close of 1865, and there are few who would be unwilling to admit its elegance and good taste. One glance at the contour of the figure is sufficient to show the full influence of the modern form of corset on the adjustment of this style of costume, and it would be a waste of both time and space to represent the figure in its uncultivated form similarly arrayed. In 1867, we find a strong tendency towards the short waists, low dresses, and long trailing trains of old times, and we are forcibly reminded, when contemplating the passing caprice, of the lines from a parody on the "Banks of Banna"—

"Shepherds, I have lost my waist.

 Have you seen my body?"

Still the waist is by no means suffered to remain *perdu*, but, as in 1827, has to be laced with very considerable tightness to compensate the eye for its loss of taperness and length. The annexed illustration represents a lady of fashion of 1867, and it would be a perfect work of supererogation to ask our readers how a lady so dressed would look "unlaced and unconfined." The ladies

themselves are by far the best judges of the matter, and the following letter from the *Englishwoman's Domestic Magazine* will show that the corset has to play an important part in the now-existing style of dress. Thus writes a lady who signs herself Edina:—

"Allow me to occupy a small portion of your valuable space with the subject of stays. I quite agree with A Young Baronet that all those ladies who possess that most elegant attraction, a slender waist, should not hide it so completely by shawls whenever they promenade. Excuse my offering a few remarks to facilitate that desirable object, a handsome figure. Ladies, when dressing for the afternoon walk or ride, or the evening display, when putting on their stays at first, should not lace them quite tight; in about a quarter of an hour they might again tighten them, and in the course of half-an-hour or so lace them to the requisite tightness. They may fancy in this way there is no sudden compression of the waist, and the figure gets more easily accustomed to tight-lacing. Occasionally, in France, ladies who are very particular about their figures have their corsets made in three pieces, laced down the sides as well as behind, and cut away over the hips; the holes for the laces are very numerous and close together. This form of corset offers great facilities for the most perfect adjustment to the figure, as well as power of tight-lacing when required, and perfect ease in walking or dancing. I may add that, in order to insure a good fit and to keep it properly in its place, the busk in front, and the whalebones behind, are made somewhat longer than the present fashion. Perhaps the lady in your September number, who signs herself An Inveterate Tight-Lacer, might find a trial of a corset made in this form a great boon as well as a comfort in tight-lacing."

Practical hints such as these will not fail to be of interest to the reader. Numerous inquiries, as will be seen on reference to the foregoing correspondence, have been made as to what circumference the waist should be to meet the requirements of elegance.

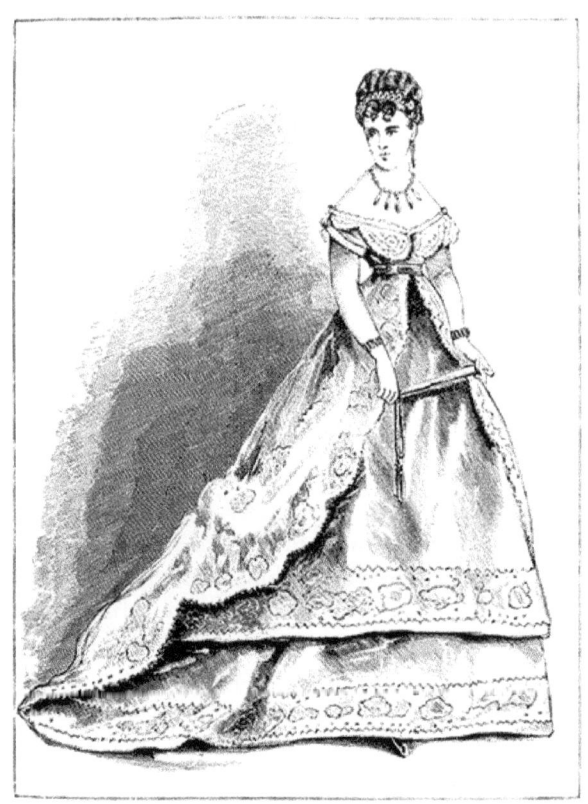

The Fashion of 1867

It must be borne in mind, when dealing with this question, that height and breadth of shoulder have much to do with proportionate slenderness of waist. A lady who is tall and wide-shouldered would appear very neatly shaped with a waist laced to twenty or twenty-one inches, whilst with a slight, narrow form of figure that size would carry the appearance of much clumsiness with it. Madame La Sante says—"A waist may vary in circumference from seventeen to twenty-three inches, according to the general proportions of the figure, and yet appear in all cases slender and elegant." We have abundant evidence before us, however, that seventeen inches is by no means the lowest standard of waist-measure to be met with in the fashionable circles of either London, New York, Paris, or Vienna. Numbers of corsets sixteen inches at the waist, and even less, are made in each of these cities every day. In the large provincial towns, both at home and abroad, corset-makers follow out the rules laid down by fashion. We are disposed to think, therefore, dealing with the evidence before us, that a lady of medium stature and average breadth of shoulder would be subscribing to

the laws of fashionable taste if the circumference of her waist was not more than from seventeen to nineteen inches, measuring outside the dress.

Fashion has indulged in some strange freaks regarding the length and position of the waist, as a reference to many of the illustrations will show, but its true position can be laid down so clearly that no doubt need remain on the matter. A line drawn midway between the hip and the lowest rib gives the exact point from which the tapering form of the waist should spring, and by keeping this rule in view it appears the statement made by so many ladies (that provided ample space is allowed for the chest the waist may be laced to an extreme of smallness without injury) has much truth to support it. The contributors to works of popular instruction even in our own day are very lavish in their denunciations of the practice of wearing corsets, and, following in the track of the ancient writers on the same subject, muster such a deadly and tremendously formidable array of ailments, failings, and diseases as inseparably associated with the wearing of that particular article of attire, that the very persons for whom these terrors are invoked, seeing from their own daily experience how overdrawn they are and how little knowledge their authors show about the subject, laugh the whole matter to scorn and follow the fashion. We have now before us a very talented and well-conducted journal, in which there are some sweeping blows at the use of both corsets and high-heeled boots or shoes, and, as an instance of the frightfully severe way in which the ladies of the time (1842) laced themselves, the writer assures us that he had actually seen a young lady's waistbelt which measured exactly "*twenty-two* inches," "showing that the *chest* to which it was applied had been reduced to a diameter (allowing for clothes) of little more than seven inches." The chest is thus shown as being about one inch less than the waist. Now, in 1842 it must have been a very eccentric lady indeed who formed her waist round her *chest*, and as to the twenty-two-inch waistband, we cannot help thinking that the majority of our readers would seek one of considerably smaller size as an indication of the practice of tight-lacing in the owner. And now on the score of high-heeled boots and slippers, we are, like the immortal boy in *Pickwick*, "going to make your flesh creep." In writing of these terrible engines of destruction our mentor says—"From the uneasiness and constraint experienced in the feet sympathetic affections of a dangerous kind often assail the stomach and chest, as hæmorrhage, apoplexy, and consumption. Low-heeled shoes, with sufficient room for the toes, would completely prevent all such consequences."

How the shareholders of life assurance companies must quake in their shoes as the smart and becoming footgear of the period meets their distracted vision at every turn! and what between the fatal high heels and waists of deadly taperness, it is a wonder that female existence can continue, and that all the policies do not fall due in less than a week, all the undertakers sink

into hopeless idiocy in a day from an overwhelming press of business, and all the gentlemen engage in sanguinary encounter for the possession of the "*last woman*," who has survived the common fate by reason of her barefooted habits and of her early abandonment of stays.

We do not find, as a matter of fact, that the Registrar-General has his duties materially increased, or that the bills of female mortality are by any means alarming, although on a moderate calculation there are considerably over twelve million corsets in the United Kingdom alone, laced with as many laces round as many waists every day in the week, with, in many instances, a little extra tension for Sundays.

We learn from the columns of *Once a Week* that the total value of stays made for British consumption annually, cannot be less than £1,000,000 sterling, to produce which about 36,000,000 yards of material are required. The stay trade of London employs more than 10,000 in town and country, whilst the provincial firms employ about 25,000 more; of these, about 8,000 reside in London, and there is about one male to every twenty-five women. Returns show that we receive every year from France and Germany about 2,000,000 corsets. One corset-manufacturer in the neighbourhood of Stuttgard has, we are informed, over 1,300 persons in constant employment, and turns out annually about 300,000 finished corsets. Messrs. Thomson and Co., the manufacturers of the glove-fitting corset, turn out incredible numbers from their immense manufactories in England, America, and on the continent. It will be readily conceived that the colonial demand and consumption is proportionately great. The quantity of steel annually made use of for the manufacture of stay-busks and crinolines is perfectly enormous. Of the importance of the whale fishery, and the great value of whalebone, it will be needless to speak here, further than to inform our readers that more than half the whalebone which finds its way into the market is consumed by the corset-makers. Silk, cotton, and wool, in very large quantities, are either spun up into laces or used in the sewing or manufacture of the corset itself. No inconsiderable quantity of timber is made use of for working up into busks. Oxhorn, ebonite, gutta-percha, and hardened brass are all occasionally used for the same purpose, whilst the brass eyelet-holes, of which we shall have to say more by-and-by, are turned out in such vast and incalculable quantities, that any attempt at computing their number would be useless. It will be seen by these statistics and remarks that, unlike certain other articles of raiment which have reigned in popular esteem for a time, and then passed away, the corset has not only become an established institution throughout the whole civilised world, but is of immense commercial importance, and in rapidly-increasing demand and esteem.

We shall now have to remark on some of the most noteworthy forms of the corset worn at the present day, contrasting them with those of the olden

time. The steel corset-*covers* we have already figured and described. On these contrivances being found heavy and too unbending in their construction, a form of corset was, as we have before said, contrived, which needed no cover to preserve its perfect smoothness of surface and rigidity of form; the front was therefore enriched with gold and silver tissue, and ornamented with embroidery, performing the part of both corset and stomacher, whilst the back was made of a heavier material, because the dress of the period often concealed it.

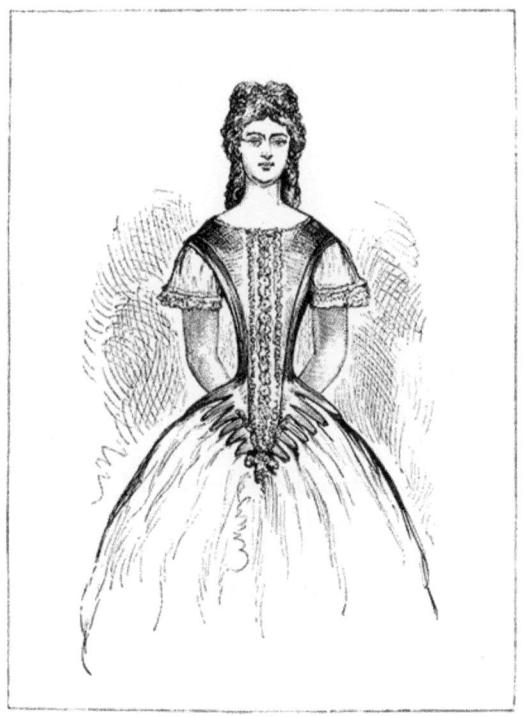

Corset, forming both Corset and Stomacher (Front).

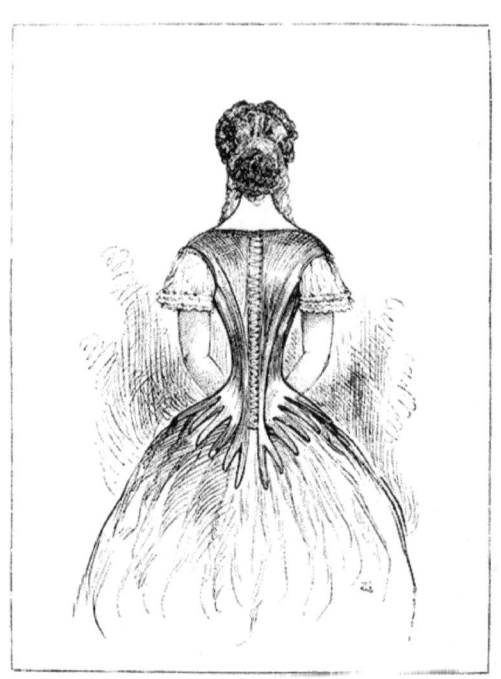

Corset, forming both Corset and Stomacher (Back).

The annexed illustrations are carefully sketched from a very excellent specimen of this form of corset or bodice, kindly lent us for the purpose by Messrs. Simmons, the well-known costumiers of Tavistock-street, Covent Garden, by whom it has been preserved as a great curiosity. The materials used in its construction are very strong, whilst every part the least liable to be put out of form is literally plated with whalebone, making its weight considerable. The lace-holes are worked with blue silk, and are very numerous and close together.

CHAPTER X.

Remarks on front-fastening stays—Thomson's glove-fitting Corsets—Plan for adding stability to the front-fastening Corset—De la Garde's French Corset—System of self-measurement—The Redresseur Corset of Vienna and its influence on the figures of young persons—Remarks on the flimsy materials used in the manufacture of Corsets—Hints as to proper materials—The "Minet Back" Corset described—Elastic Corsets condemned—The narrow bands used as substitutes for Corsets injurious to the figure—Remarks on the proper application of the Corset with the view to the production of a graceful figure—Thomson's Zephyrina Crinoline—Costume of the present season—The claims of Nature and Art considered—The belle of Damara Land.

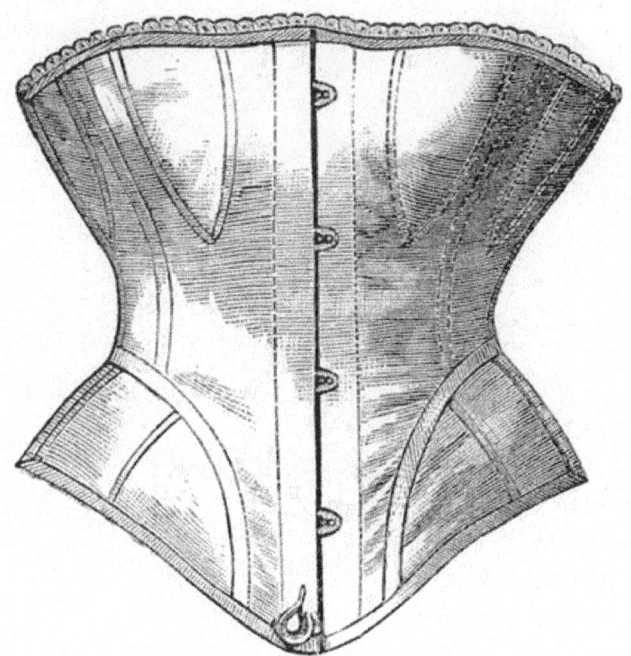

Common Cheap Stay, Fastened.

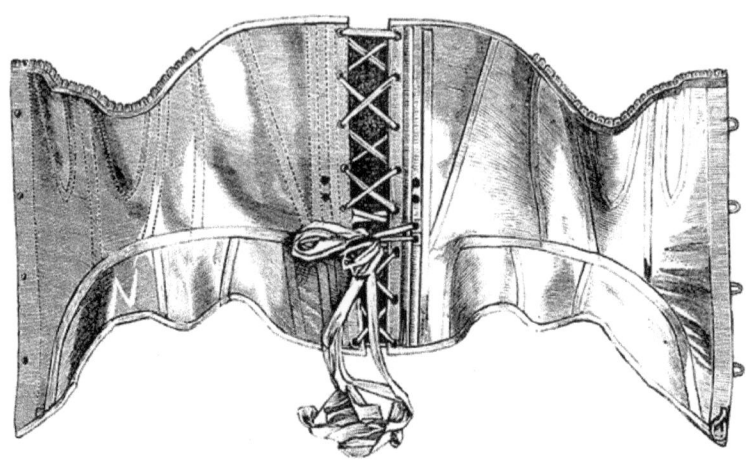

Common Cheap Stay, Open.

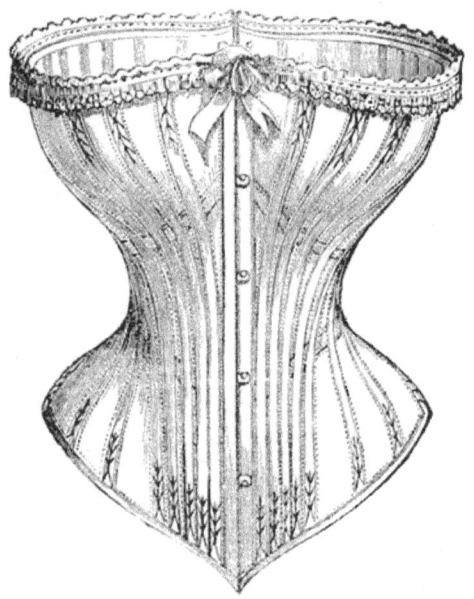

The Glove-Fitting Corset (Thomson and Co.)

IT would be difficult to find a much more marked contrast to the style of bodice referred to in our last chapter than is to be found in the ordinary cheap front-fastening corset commonly sold by drapers. The accompanying illustrations accurately represent it, and those who have written on the subject have much reason on their side when they insist that it neither aids in the formation of a good figure nor helps to maintain the proportions of

one when formed. Corsets such as these have neither beauty of contour nor compactness of construction. The two narrow busks through which the holes are drilled for the reception of the *studs* or *catches* are too often formed of steel so low in quality that fracture at these weak points is a common occurrence, when some danger of injury from the broken ends is to be apprehended. It will also be found that when these bars or plates are deficient in width and insufficient in stiffness the corset will no longer support the figure, or form a foundation for the dress to be neatly adjusted over. On the introduction of the front-fastening system it was at once seen that much saving of time and trouble was gained by the great facility with which corsets constructed according to it could be put on and off but the objections before referred to were soon manifest, and the ingenuity of inventors was called into action to remedy and overcome them, and it was during this *transition* stage in the history of the corset that the front-fastening principle met with much condemnation at the hands of those who made the formation of the figure a study. From Thomson and Co., of New York, we have received a pattern of their "*glove-fitting corset*," the subject of the accompanying illustration, in the formation of which the old evils have been most successfully dealt with. The steels are of the highest class of quality and of the requisite degree of substance to insure both safety and sustaining power. Accidental unfastening of the front, so common, and, to say the least of it, inconvenient, in the old form of attachment, is rendered impossible by the introduction of a very ingenious but simple spring *latch*, which is opened or closed in an instant at the pleasure of the wearer. This corset is decidedly the best form on the front-fastening plan we have seen. Its mode of construction is excellent; it is so cut as to admit of its adapting itself to every undulation of the figure with extraordinary facility. We have suggested to the firm the advisability of furnishing to the public corsets combining their excellent method of cutting, great strength of material, and admirable finish, with the single steel busk and hind-lacing arrangement of the ordinary stay. The requirements of all would be then met, for although numbers of ladies prefer the front-fastening corset, it will be observed that a great number of those who have written on the subject, and make the formation and maintenance of the figure a study, positively declare from experience that the waist never looks so small or neatly proportioned as when evenly and well laced in the hind-lacing and close-fronted form of corset. It has of late become the custom to remedy the want of firmness and stability found to exist in many of the common front-fastening corsets by sewing a kind of sheath or case on the inside of the front immediately behind the two steels on which the studs and slots are fixed; into this a rather wide steel busk is passed, so that the division or opening has the centre line of the *extra* busk immediately behind it. That this plan answers in some measure the desired end there is no doubt, but in such a corset as that of Thomson and Co. no such expedient is needed.

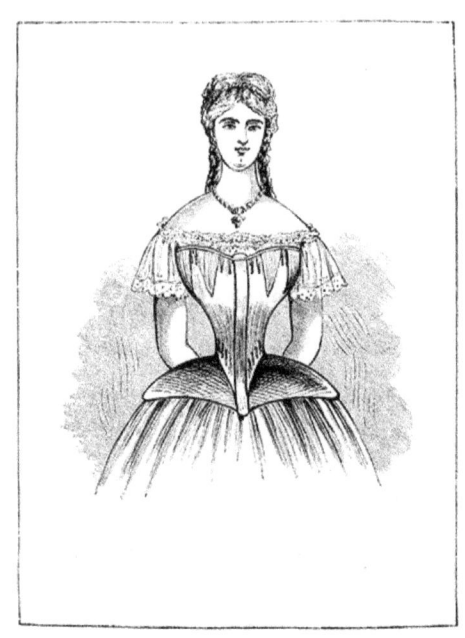

Corset of Messrs. De La Garde, Paris (Front).

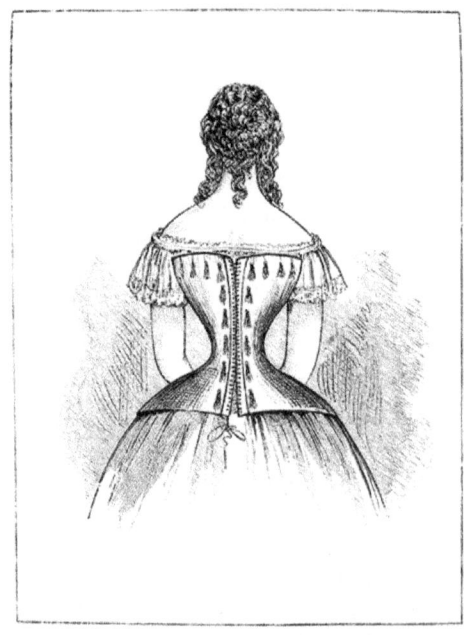

Corset of Messrs. De La Garde, Paris (Back).

The accompanying illustrations are from sketches made expressly for this work from a corset made by De La Garde and Co., of Paris, and our readers will form their own opinion as to the contour of the figure from which these drawings were made, which is that of a lady who has for many years worn corsets made by the above-mentioned firm. The waist-measure is eighteen inches. The remarks as to the advisability of having corsets made to measure are scarcely borne out by her experiences. She informs us that it has always been her custom to forward to Messrs. De La Garde and Co.'s agent the measure taken round the chest below the arms, from beneath the arm to the hip, the circumference of the hips, and the waist-measure, when the fit is a matter of certainty. By adopting this system ladies residing in the country can, she assures us, always provide themselves with corsets made by the first manufacturers in Europe without the trouble and inconvenience of being attended for the purpose of measurement. In ordering the "*glove-fitting corset*," the waist measure only need be given. From M. Weiss, of Vienna, we have received a pattern and photographs from which our other illustrations are taken. Here we have represented the so-called "*redresseur*" corset, devised mainly with a view to the formation of the figure in young persons, or where careless and awkward habits of posture have been contracted. It will be seen on examination that the front of the chest is left entirely free for expansion, the waist only being confined at the point where restraint is most called for. The back is supported and kept upright by the system of boning adopted with that view, and the shoulder-straps, after passing completely round the point of the shoulder, are hooked together behind, thus bringing the shoulders in their proper position and keeping them there. As a corrective and improver to the figure there can be no doubt that the *redresseur* corset is a safe and most efficient contrivance. We have had an opportunity of seeing it worn, and can testify to the marked and obvious improvement which was at once brought about by its application.

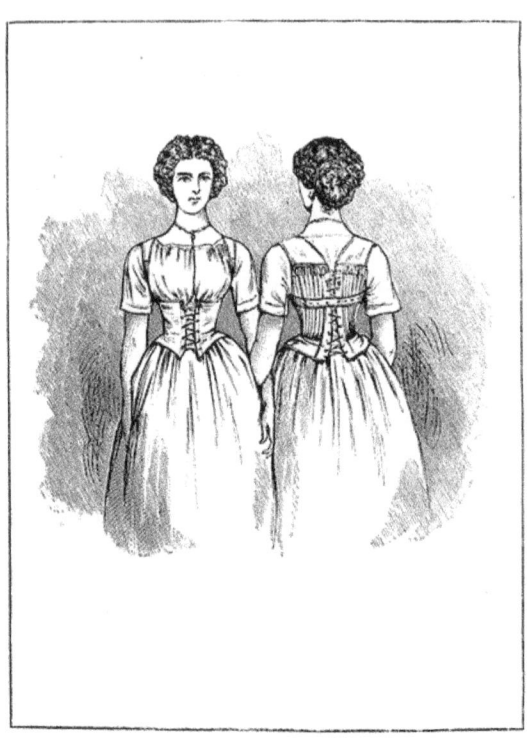

The "Redresseur" Corset of Vienna (Weiss).

We have heard many complaints lately of the flimsy manner in which corsets of comparatively high price are turned out by their makers, the stitching being so weak that re-sewing is not unfrequently needed after a few days' wear. The edges of the whalebones, too, instead of being rounded off and rendered smooth, are often, we find, left as sharp as a knife, causing the coutil or other material to be cut through in a very few days. The eyelet-holes are also made so small and narrow at the flanges that no hold on the material is afforded, and even the most moderate kind of lacing causes them to break from their hold, fall out, and leave a hole in the material of which the corset is made, which if not immediately repaired by working round in the old-fashioned way rapidly enlarges, frays out, and runs into an unsightly hole. Corset-makers should see that the circle of metal beyond the orifice through which the lace passes is sufficiently wide to close down perfectly on the fabric, and retain a firm hold of it; if they do not do so, the old worked eyelet-hole is preferable to the stud, notwithstanding the neat appearance of the stud and the apparent advantage it has over the old plan. A form of corset made without lacing-holes, known as the "*Minet Back*," with which many of our readers will no doubt be familiar, and which was extensively worn in

France some few years ago, is still to be obtained of some few makers in England. This has a row of short strong loops sewn just beyond each back whalebone. Through these pass from top to bottom, on each side of the back, a long round bar of strong whalebone, which is secured in its place by a string passing through a hole made in its top to the upper loop of each row. The lace (a flat silk one) was passed through the spaces between the loops, and was tightened over the smooth round whalebone, thus enabling the wearer not only to lace with extreme tightness without danger to the corset, but admitting of its almost instant removal by slightly slackening the lace and then drawing out one of the bars, which immediately sets the interlacing free from end to end. We are rather surprised that more of these corsets are not worn, as there are numerous advantages attendant on them. Our space will not admit of our more than glancing *en passant* at the various inventions which have from time to time been brought to the notice of the public. By some inventors the use of elastic webbing or woven indiarubber cloth was taken advantage of, and great stress was laid on the resilient qualities of the corsets to which it was applied. But it must never be lost sight of that all materials of an elastic nature, when fitted tightly to the figure, not only have the power of expanding on the application of force, but are unceasingly exercising their own extensive powers of contraction. Thus, no amount of custom could ever adapt the waist to the space allotted to it, as with the elastic corset it is changing every second, and always exercising constriction even when loosely laced. The narrow bands hollowed out over the hips may be, as some writers on the subject have stated, adapted for the possessors of very slight figures who ride much on horseback; but many ladies of great experience in the matter strongly condemn them as being inefficient and calculated to lead to much detriment to the figure. Thus writes a correspondent to the *Englishwoman's Domestic Magazine*:—

> "As one of your correspondents recommends the waistbands in lieu of corsets, I have during the last three weeks made a trial of them, and shall be glad if you will allow me to express my opinion that they are not only disadvantageous but positively dangerous to the figure. Your correspondent says that ordinary corsets, if drawn in well at the waist, hurt a woman cruelly all the way up. I can only say that if she finds such to be the case the remedy is in her own hands. If ladies would only take the trouble to have their stays made to measure for them, and have plenty of room allowed round the chest, not only would the waist look smaller, but no discomfort would be felt such as H. W. describes. Young girls should always be accurately fitted, but it is, I have found, a mistake to have their corsets too flimsy or elastic. I quite agree that they should be

commenced early—indeed, they usually are so, and thus extreme compression being unnecessary, the instances brought forward by the lady who commenced the discussion and by Nora must, I think, be looked upon as exceptional cases.

"EFFIE MARGETSON."

Another lady writing in the same journal says—"No one will grudge 'The Young Lady Herself' any sympathy she may claim for the torture she has submitted to, but so far from her case being condemnatory of stays it is the reverse, for she candidly admits that she does not suffer ill-health. Now such a case as hers is an exception, and the stout young lady spoken of by Nora is also an exception, for it is seldom that girls are allowed to attain the age of fourteen or fifteen before commencing stays. The great secret is to begin their use as early as possible, and no such severe compression will be requisite. It seems absurd to allow the waist to grow large and clumsy, and then to reduce it again to more elegant proportions by means which must at first be more or less productive of inconvenience. There is no article of civilised dress which, when first begun to be worn, does not feel uncomfortable for a time to those who have never worn it before. The barefooted Highland lassie carries her shoes to the town, puts them on on her arrival, and discards them again directly she leaves the centre of civilisation. A hat or a coat would be at first insupportable to the men of many nations, and we all know how soon the African belle threw aside the crinoline she had been induced to purchase. But surely no one would argue against these necessary articles of dress merely on the ground of inconvenience to the wearer, for, however uncomfortable they may be at first, it is astonishing how soon that feeling goes off and how indispensable they become. My opinion is that stays should always be made to order, and not be of too flimsy a construction. I think H. W.'s suggestions regarding the waistbands only applicable to middle-aged ladies or invalids, as they do not give sufficient support to growing girls, and are likely to make the figure look too much like a sack tied round the middle instead of gradually tapering to the waist. Brisbane's letter shows how those who have never tried tight-lacing are prejudiced against it, and that merely from being shown a print in an old medical

work, while Nora's letter is infinitely more valuable, as showing how even the most extreme lacing can be employed without injury to health.

<div style="text-align: right">"L. THOMPSON."</div>

Such a work as this would be incomplete without some remarks touching the best means to be applied for the achievement of the desired end, and hence a letter from a lady of great experience, who has paid much attention to the subject, contributed to the *Englishwoman's Domestic Magazine*, enables us to give the very best possible kind of information—viz., that gathered by personal observation. Thus she writes:—

"In the numerous communications on the subject of tight-lacing which have appeared in the *Englishwoman's Domestic Magazine*, but little has been said on the best mode of applying the corset in order to produce elegance of figure. It seems to me that nearly all those who suffer from tight-lacing do so from an *injudicious* use of the corset, and in such cases the unfortunate corset generally gets all the blame, and not the wearer who makes an improper use of it. I can easily understand that a girl who is full grown, or nearly so, and who has been unaccustomed to wear tight stays, should find it difficult and painful to lace in her waist to a fashionable size; but if the corset be worn at an early age and the figure gradually moulded by it, I know of no terrible consequences that need be apprehended. I would therefore recommend the early use of a corset that fits the figure nicely and no more. Now, simply wearing stays that only *fit*, will, when a girl is growing, in a great measure prevent the waist from becoming clumsy. If, however, on her reaching the age of fourteen or fifteen, her waist be still considered too large, a smaller corset may be worn with advantage, which should be *gradually* tightened till the requisite slimness is achieved. I know of so many instances in which, under this system, girls have, when full grown, possessed both a good figure and good health, that I can recommend it with confidence to those parents who wish their children to grow up into elegant and healthy women. As to whether compression of the waist by symmetrical corsets injures the health in any way, opinion seems to be divided. The personal experiences of tight-lacers, as your correspondent Belle has observed, will do more to solve this knotty question than any amount

of theory. But whatever conclusion we may come to on this point, there is no denying the fact that very many of the strongest and healthiest women one sees in society habitually practise tight-lacing, and apparently do so with impunity.

<div align="right">"An Old Subscriber."</div>

As we have before stated, the remarks and observations contained in the above letter are the result of careful study and a thorough acquaintance with the subject, and not of hasty conclusion, prejudice, or theory. A letter in the earlier portion of this work, from an old Edinburgh correspondent to the *Queen*, than whom few are more competent to direct and advise on this important subject, will be found precisely to the same end, and we feel sure, in laying before the reader such united experiences, that much will be done towards the establishment of such a system of management as will lead to the almost certain achievement of grace and elegance of figure without the sacrifice of health. That these are most important and desirable objects for attainment few would be puritanical and headstrong enough to deny, and there can be no question that, however superb or simple a lady's costume may be, it is mainly dependent for its elegance of adjustment and distinctiveness of style to the corset and crinoline beneath it.

We have seen how Mrs. Selby's invention influenced the world of fashion in her day, and a glance at the illustration at page 114 will be sufficient to prove how inferior, in point of grace and elegance, the costume of that period was to that of our own time. Some idea may be formed of the wide-spread and almost universal attention which Mrs. Selby's wondrous "*crinoline conception*" met at the hands of the fashionable world by a perusal of the following lines, which were written at Bath concerning it in the year 1711, and are entitled, *The Farthingale Reviewed; or, More Work for the Cooper. A paneygerick on the late but most admirable invention of the hooped petticoat.*

"There's scarce a bard that writ in former time

 Had e'er so great, so bright a theme for rhyme;

 The *Mantua* swain, if living, would confess

 Ours more surprising than his Tyrian dress,

 And Ovid's mistress, in her loose attire,

 Would cease to charm his eyes or fan Love's fire.

 Were he at *Bath*, and had these coats in view,

 He'd write his *Metamorphosis* anew,

Delia, fresh hooped, would o'er his heart prevail,
To leave Corinna and her tawdry veil.
Hear, great Apollo! and my genius guide,
To sing this glorious miracle of pride,
Nor yet disdain the subject for its name,
Since meaner things have oft been sung to Fame;
Even boots and spurs have graced heroic verse,
Butler his knight's whole suit did well rehearse;
King Harry's costume stands upon record,
And every age will precedents afford.
Then on, my Muse, and sing in epic strain
The petticoat—thou shalt not sing in vain,
The petticoat will sure reward thy pain;
With all thy skill its secret virtues tell—
A petticoat should still be handled well.

"Oh garment heavenly wide! thy spacious round
Do's my astonished thoughts almost confound;
My fancy cannot grasp thee at a view,
None at first sight e'er such a picture drew.
The daring artist that describes thee true,
Must change his sides as modern statesmen do,
Or like the painter, when some church he draws,
Following his own, and not the builder's laws,
At once shows but the prospect to the sight,
For north and south together can't be right.

"Hence, ye profane! nor think I shall reveal
The happy wonders which these vests conceal;
Hence your unhallow'd eyes and ears remove,
'Tis *Cupid's* circle, 'tis the orb of Love.

Let it suffice you see th' unwieldy fair
Sail through the streets with gales of swelling air;
Nor think (like fools) the ladies, would they try,
Arm'd with their furbelows and these, could fly.
That's all romantick, for these garments show
Their thoughts are with their petticoats below.

"Nor must we blame them whilst they stretch their art
In rich adornment and being wondrous smart;
For that, perhaps, may stand 'em more in stead
Than loads of ribbons fluttering on the head.
And, let philosophers say what they will,
There's something surer than their eyes do's kill;
We tell the nymph that we her face adore,
But plain she sees we glance at something more.

"In vain the ladies spend their morning hours
Erecting on their heads stupendous towers;
A battery from thence might scare the foe,
But certain victory is gained below.
Let *Damon* then the adverse champion be—
Topknots for him, and petticoats for me;
Nor must he urge it spoils the ladies' shape,
Tho' (as the multitude at monsters gape)
The world appears all lost in wild amaze,
As on these new, these strange machines they gaze;
For if the Queen the poets tell us of, from Paphos came,
Attired as we are told by antique fame,
Thus would they wonder at the heavenly dame.

"I own the female world is much estranged

From what it was, and top and bottom changed.
The head was once their darling constant care,
But women's heads can't heavy burdens bear—
As much, I mean, as they can do elsewhere;
So wisely they transferred the mode of dress,
And furnished t'other end with the excess.
What tho' like spires or pyramids they show,
Sharp at the top, and vast of bulk below?
It is a sign they stand the more secure:
A maypole will not like a church endure,
And ships at sea, when stormy winds prevail,
Are safer in their ballast than their sail.

"Hail, happy coat! for modern damsels fit,
 Product of ladies' and of taylors' wit;
 Child of Invention rather than of Pride,
 What wonders dost thou show, what wonders hide!
 Within the shelter of thy useful shade,
 Thin *Galatea's* shrivelled limbs appear
 As plump and charming as they did last year;
 Whilst tall *Miranda* her lank shape improves,
 And, graced by thee, in some proportion moves.
 Ev'n those who are diminutively short
 May please themselves and make their neighbours sport,
 When, to their armpits harnessed up in thee,
 Nothing but head and petticoats we see.
 But, oh! what a figure fat *Sempronia* makes!
 At her gigantick form the pavement quakes;
 By thy addition she's so much enlarged,
 Where'er she comes, the sextons now are charged

That all church doors and pews be wider made—
A vast advantage to a joiner's trade.

"Ye airy nymphs, that do these garments wear,
Forgive my want of skill, not want of care;
Forgive me if I have not well displayed
A coat for such important uses made.
If aught I have forgot, it was to prove
How fit they are, how *apropos* for love,
How in their circles cooling zephyrs play,
Just as a tall ship's sails are filled on some bright summer day.
But there my Muse must halt—she dares no more
Than hope the pardon which she ask'd before."

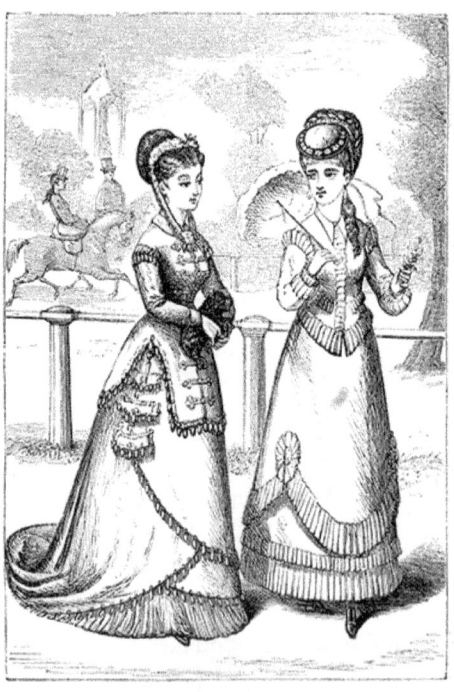

The Fashion of 1868.

Fashions have altered, times have changed, hooped petticoats have been in turn honoured and banished, just as the fickle goddess of the mirror has decreed. Still, as an arrow shot in the air returns in time to earth, so surely does the hooped jupon return to power after a temporary estrangement from the world of gaiety. The illustration on page 223 represents the last new form of crinoline, and there can be no doubt that its open form of front is a most important and noteworthy improvement. Preceding this engraving, we have an illustration representing two ladies in the costume of the present season arranged over "the glove-fitting corset" and "Zephyrina jupon," for patterns of both of which we are indebted to the courtesy of Messrs. Thomson and Co., the inventors and manufacturers.

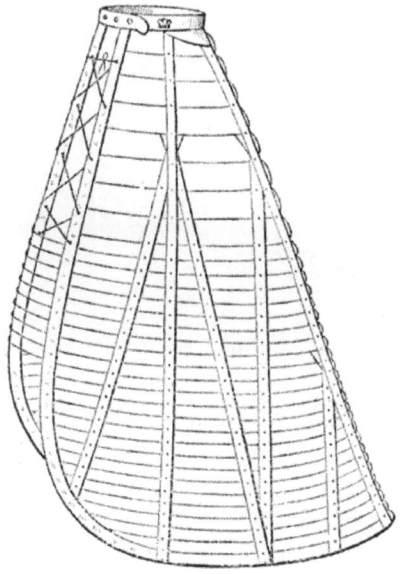

The Zephyrina Jupon.

It is the custom with some authors to uphold the claims of *nature* in matters relating to human elegance, and we admit that nature in her own way is particularly charming, so long as the accessories and surroundings are in unison. But in the human heart everywhere dwells an innate love of adornment, and untaught savages, in their toilet appliances and tastes, closely resemble the belles of highly-civilised communities. We have already referred to the crinoline petticoats worn by the Tahitian girls when they were first seen by the early navigators. The frilled ruff which so long remained a high court favourite during the Elizabethan period (and which, if we mistake not, will again have its day) was as well known to the dusky beauties of the palm-clad, wave-lashed islands of the Pacific, when Cook first sailed forth to discover new lands, as it was to the stately and proud dames of Venice.

Beneath, we place side by side types of savage elegance and refined taste. Where the one begins and the other ends, who shall say?

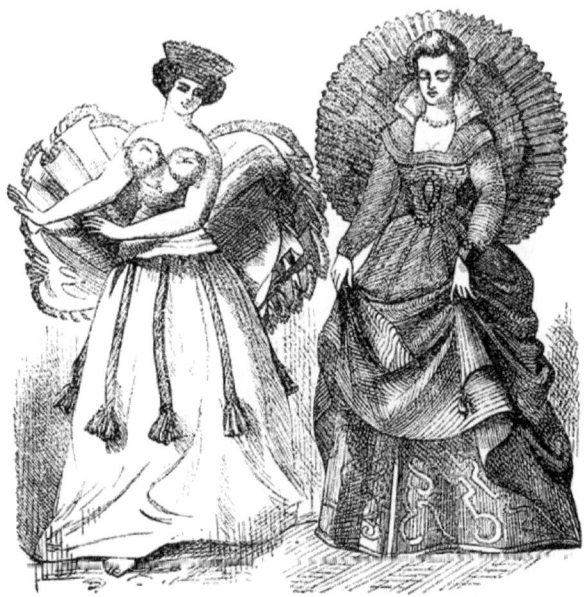

Tahitian Dancing Girl. Venetian Lady.

Milton Keynes UK
Ingram Content Group UK Ltd.
UKHW010011190124
436278UK00004B/374